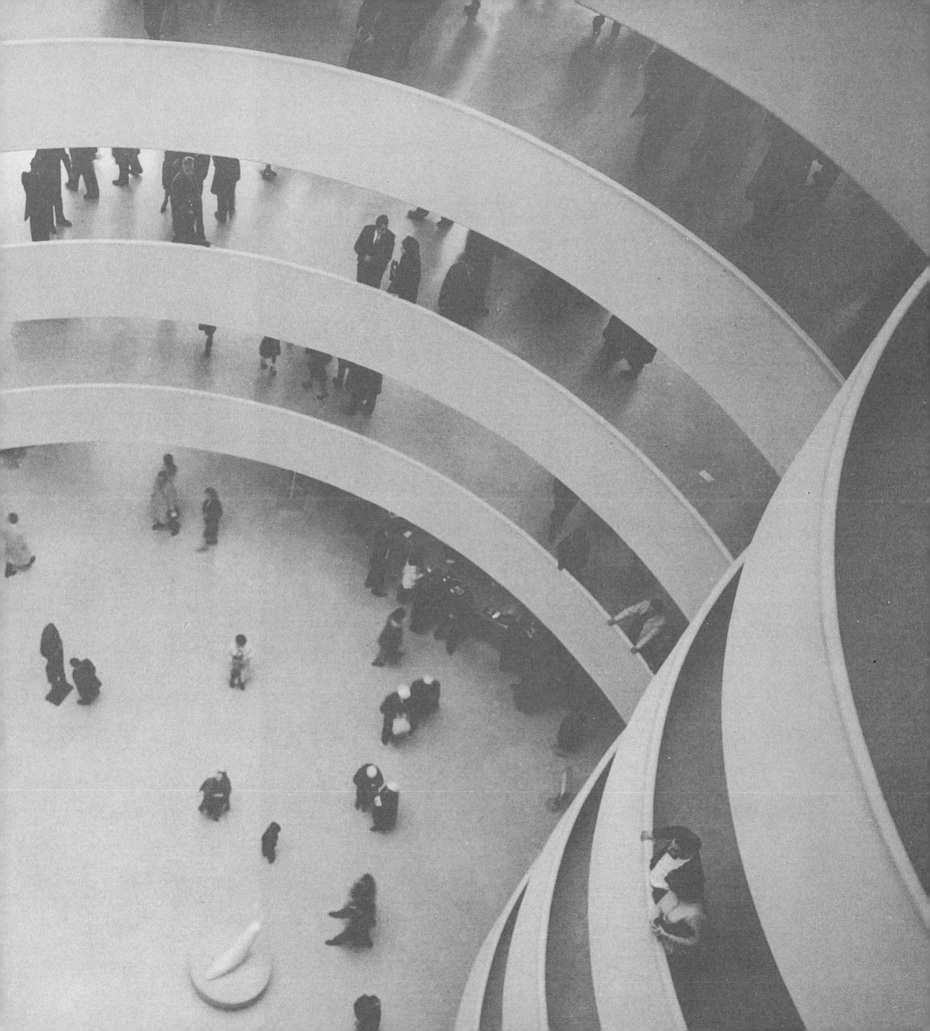

FIFTY YEARS OF COLLECTING: AN ANNIVERSARY SELECTION

SCULPTURE OF THE MODERN ERA

Fifty Years of Collecting: An Anniversary Selection

Sculpture of the Modern Era

by Thomas M. Messer

This exhibition is made possible by a generous grant from The Chase Manhattan Bank.

Alitalia is the official carrier for the presentation.

The Solomon R. Guggenheim Foundation

Library of Congress Cataloging-in-Publication Data

Messer, Thomas M.
 Fifty years of collecting.

 Includes indexes.
 Contents: 1. Painting by modern masters—2. Sculpture
of the modern era—3. Painting since World War II.
 1. Art, Modern—20th century—Exhibitions.
2. Solomon R. Guggenheim Foundation—Exhibitions.
I. Solomon R. Guggenheim Foundation. II. Title.

N6490.M473 1987 709'.04'007401471 87-20763
ISBN 0-89207-064-1 (v. 1)
 0-89207-065-x (v. 2)
 0-89207-066-8 (v. 3)

Published by The Solomon R. Guggenheim Foundation, New York, 1987

Printed in Italy

cover: cat. no. 19, Constantin Brancusi, *The Muse (La Muse)*. 1912

TABLE OF CONTENTS

DONORS TO THE COLLECTION INCLUDED IN THE EXHIBITION

Louis and Bessie Adler Foundation, Inc.

The American Art Foundation

Mrs. Jean Arp

The Associates Committee

Miss Sally Austin

Mr. and Mrs. Marcel Breuer

Pol Bury

C. and B. Foundation

Alexander Calder

B. Gerald Cantor Art Foundation

Estate of Katherine S. Dreier

Jean Dubuffet

Mrs. Andrew P. Fuller

Fuller Foundation

Harry F. Guggenheim

Peggy Guggenheim

Solomon R. Guggenheim

The Merrill G. and Emita E. Hastings Foundation

Family of Eva Hesse

Mr. and Mrs. Morton L. Janklow

Mr. and Mrs. Donald Lee Jonas

Junior Associates Committee

Carmen Martinez and Viviane Grimminger

Professor and Mrs. Alexander Melamid

Dominique and John de Menil

Mr. and Mrs. Irving Moskovitz

National Endowment for the Arts

Dr. Milton D. Ratner

Collection Mary Reynolds through her brother

Frank Ribelin

Mr. and Mrs. Irving Rossi

Mr. and Mrs. Andrew M. Saul

The SCALER Foundation, Eric and Sylvie Boissonnas

The Gerald E. Scofield Bequest

Mr. and Mrs. James J. Shapiro

Evelyn Sharp

Mr. and Mrs. Sidney Singer

Stephen and Nan Swid

Justin K. Thannhauser

The Theodoron Foundation

The Walter Foundation

Eleanor Ward

Mr. and Mrs. Stephen S. Weisglass

Ruth and Philip Zierler

SPONSOR'S STATEMENT

We at Chase are pleased to sponsor the Guggenheim's exhibition of master-works of European and American art, which has been planned as part of the Museum's fiftieth anniversary celebration.

The exhibition offers a broad look at twentieth-century art—from Impressionism through Cubism and Surrealism to Abstract Expressionism and more recent postwar movements—and brings together, for the first time, artworks from the permanent collection of the Guggenheim Museum in New York and from the Peggy Guggenheim Collection in Venice. It is a privilege for us to help bring to public view these outstanding works.

Sponsoring this presentation is just one way we are continuing Chase's partnership with the arts, which has been going strong for thirty years through our philanthropic contributions and our corporate art collection, which contains many works by the artists represented here.

WILLARD C. BUTCHER, *CHAIRMAN OF THE BOARD*
THE CHASE MANHATTAN BANK

PREFACE AND ACKNOWLEDGMENTS

Anniversaries are simultaneously retrospective and prospective occasions. For a brief moment time must have a stop while we assess a momentary and imaginary juncture between what has passed and what may lie ahead. Emphasis and commitment are rightly reserved for the unfathomable future but even its partial intuition depends upon notions derived from the past.

It was fifty years ago that The Solomon R. Guggenheim Foundation, today the parent body of two museums, one in New York and one in Venice, was established, and therefore a half-century span of collecting can be reviewed in this year of 1987. The moment coincides with a manifest need to bring a half-hidden collection into fuller view, and even the very partial success of this endeavor in the Foundation's anniversary year is to us cause for satisfaction while also serving as an augury of future fulfillment.

To reach such goals the Trustees of The Solomon R. Guggenheim Foundation years ago authorized a sizeable enlargement of Museum spaces to be reserved for the presentation of the permanent collection—resulting in an effort that has consumed much of the past decade. Only its first phase has so far been realized, yielding the stage for the collection survey recorded in this publication.

The selection has been drawn from our entire holdings and is divided into three parts, each of which is provided with a separate picture book. The sequence begins with painting by modern masters, shown on two floors on the Museum's north side which have been reconstituted as galleries since the opening of the Frank Lloyd Wright building in 1959. Part of the modern masters presentation is installed in the Thannhauser Wing, which has just been rebuilt, and a new gallery to its east, created within the past year. The presentation's middle section, occupying all but the two top ramps of the grand spiral, has been reserved for sculpture, ranging from its modern origins to the current decade. The remaining ramps, of which the uppermost has been newly reconstructed, presents highlights from the postwar collection of painting in three consecutive chapters beginning with Europe, proceeding with Latin America and ending with North America.

To celebrate the occasion, the finest works from the Peggy Guggenheim Collection have been integrated with the treasures of the Solomon R. Guggenheim Museum, for the first time in New York, thus emphasizing the richness and range of the two collections held in custody by the Foundation whose anniversary is being observed. It should be noted in this context that no loans or even promised gifts are included in the presentation, so that its full significance remains undiluted.

But pride and satisfaction, appropriate sentiments we trust for a commemorative occasion, remain linked to an awareness of persisting insufficiencies. The provisional quality of the gallery spaces, with whatever temporary awkwardness may be apparent in this intermediary building stage, imposes reservations upon our contentment. We are also aware of the need to prune and

enrich the collection in areas of weakness that still prevail—an undertaking increasingly difficult at a time of high prices and low income. But more than a beginning has been made in what must be a continuing process, and the generosity of the Museum's friends in the past justifies optimism as this institution moves into its second half-century.

The first to be thanked in this context are the members of the Foundation's Board of Trustees who, under the Presidency of Peter Lawson-Johnston, have provided essential material and moral support for the acquisition process over an extended period of time. Equally decisive and therefore deserving of gratitude are various past contributions by the Guggenheim's Curatorial staff, in recent years particularly those of Diane Waldman, the Museum's Deputy Director, who has shared with me responsibility for acquisitions in the area of postwar art.

Among the many benefactors to whom we are grateful are the donors of works in the current selection, whose names are listed elsewhere in this catalogue. Thanks must be expressed to the staffs of both the Guggenheim Museum in New York and the Peggy Guggenheim Collection in Venice, which made extraordinary efforts on behalf of the exhibition and catalogues. The most centrally involved at the Solomon R. Guggenheim Museum were Lisa Dennison, Assistant Curator, who coordinated the effort with the assistance of Nina Nathan Schroeder, Curatorial Assistant; Karyn Zieve, National Endowment for the Arts Curatorial Fellow; Carol Fuerstein, Editor; and Diana Murphy, Assistant Editor. At the Peggy Guggenheim Collection Philip Rylands, Deputy Director, and his assistant Renata Rossani provided analogous services.

Our deepest and most sincere appreciation is due to The Chase Manhattan Bank for the generous grant they provided for the exhibition. We are grateful to Alitalia for the transportation of works of art for the presentation. We are indebted to these organizations, as well as to the many other benefactors whose enlightened support has assured the viability of our programs over the years.

THOMAS M. MESSER, *DIRECTOR*
THE SOLOMON R. GUGGENHEIM FOUNDATION

SCULPTURE OF THE MODERN ERA

This second installment of the Guggenheim's fiftieth anniversary show is devoted to sculpture as presented on four ramps as well as in the so-called High Gallery and in the Rotunda of Frank Lloyd Wright's architectural masterpiece. The decision to place sculpture in these spaces was predicated upon the realization that the medium accommodates itself with special grace to the bays and webs of the spiral as well as to the sections of flat floor issuing from them. Sculpture was not part of the collection when the building was commissioned, and no special provisions for its presentation were made. The first sculpture show on the ramps of the Guggenheim was a selection from the Joseph H. Hirshhorn Collection, presented in 1962, which served as tangible proof that the building could be used to advantage for the three-dimensional medium, a claim that was much contested in those days.

Sculpture was not included in The Solomon R. Guggenheim Foundation's original collection because the first institution operated by that parent body was the Museum of Non-Objective Painting. The deliberate limitation to painting had to do with a prevailing emphasis upon the spiritual in art and the supposition that the corporeality of three-dimensional objects would undermine this attribute. Sculpture nevertheless was bought for the Museum's collection in exceptional instances, when, as with the work of Gabo, Moholy-Nagy and Calder, its dematerialized form did not appear to be in conflict with the non-objective orientation.

Sculpture thus could truly make its entry into the collection only after the Museum of Non-Objective Painting was renamed the Solomon R. Guggenheim Museum in 1952 and after the dogma attached to the institution's earlier incarnation was abandoned. There was then, with respect to sculpture, much lost time to be made up, and James Johnson Sweeney, the incoming Director, proceeded at full speed with major acquisitions, which form the basis of the collection of twentieth-century sculpture that now exists at the Guggenheim. With the exception of the painter-sculptors Picasso and Matisse, virtually all the masters (Maillol, Duchamp-Villon, Archipenko, Lipchitz, Modigliani, Arp, Pevsner, Ernst, Giacometti, Moore and Miró, among others) were acquired in the course of the 1950s. Works by the greatest among these, Constantin Brancusi, were added to the collection in impressive depth, thereby establishing the Guggenheim as one of the principal repositories of his art.

Thereafter sculpture remained on the Guggenheim's collecting agenda, as is borne out by subsequent acquisitions of works dating from the 1960s and later by, among many others, Beuys, Chillida, Caro, Ipoustéguy in Europe and David Smith, Noguchi, Nevelson in America, as well as of examples by an earlier generation of artists including Barlach, Laurens, Gutfreund and González. The most dramatic recent acquisition was the recovered Brancusi *The Muse*, the famous marble of 1912, which came back into the Foundation's possession after an absence of close to fifteen years.

The effort to deepen the collection of already classical sculpture has led to significant additions of works by Duchamp-Villon, Archipenko, Lipchitz, Brancusi, Arp, Pevsner, Ernst, Giacometti and Moore among others. The small but choice sculpture collection of Peggy Guggenheim, which, as part of her donation, became the responsibility of The Solomon R. Guggenheim Foundation after her death in 1979, played an important role in this process. As in all other parts of the current anniversary show, selections were made from the holdings of both the Solomon R. Guggenheim Museum in New York and the Peggy Guggenheim Collection in Venice, bringing works together in this Museum under Foundation auspices for the first time.

TMM

CATALOGUE

Drawings, which do not appear in the catalogue, are included in the exhibition where relevant. A portion of the installation will change in the course of the exhibition. Therefore sculpture included in the catalogue will not necessarily be on view at all times during the presentation.

The first number cited in the final line of the caption for each illustration is the Solomon R. Guggenheim Museum or the Peggy Guggenheim Collection acquisition number. The two-digit prefix in these numbers represents the year the work entered the collection. The citations SRGM coll. cat., PGC cat., SRGM hb. and PGC hb. refer to entries in the following publications: *The Guggenheim Museum Collection: Paintings 1880–1945*, New York, 1976; *Peggy Guggenheim Collection, Venice, The Solomon R. Guggenheim Foundation, New York*, New York, 1985; *Handbook: The Guggenheim Museum Collection, 1900–1980*, New York, 1980 and 1984; and *Handbook: Peggy Guggenheim Collection*, New York, 1986.

INDEX OF ARTISTS

Edgar Degas

I *Dancer Moving Forward, Arms Raised (Danseuse s'avançant, les bras levés)*. 1882–95
 Bronze, 13¾ in. (35 cm.) high
 Gift, Justin K. Thannhauser
 78.2514 T8

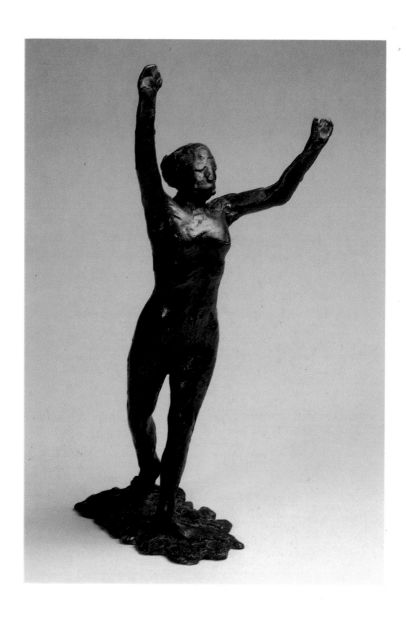

Edgar Degas

2 *Spanish Dance (Danse espagnole).* 1896–1911
 Bronze, 16 in. (40.5 cm.) high
 Gift, Justin K. Thannhauser
 78.2514 T9

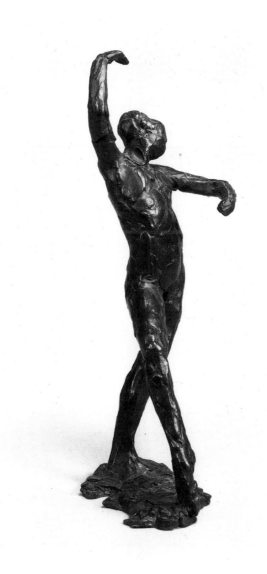

Edgar Degas

3 *Seated Woman, Wiping Her Left Side (Femme assise, s'essuyant le côté gauche).* 1896–1911
Bronze, 13¾ in. (35 cm.) high
Gift, Justin K. Thannhauser
78.2514 T10

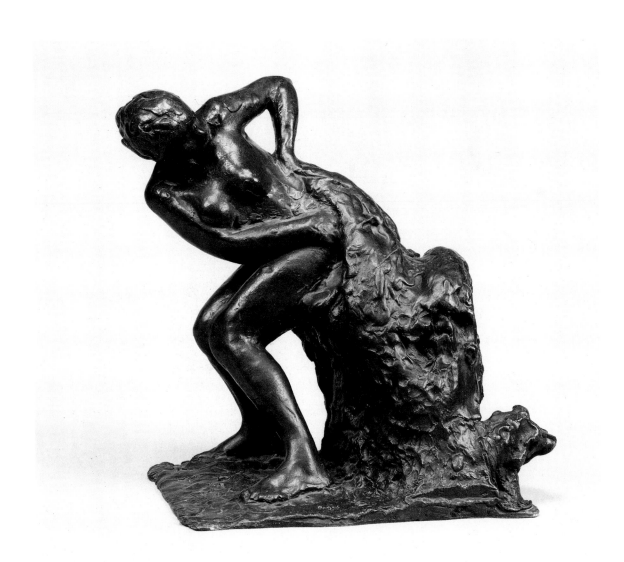

Aristide Maillol

4 *Woman with Crab (La Femme au crabe)*. 1902(?)–05
Bronze, 6 x 5¾ x 4¾ in. (15.2 x 14.6 x 12.1 cm.)
Gift, Justin K. Thannhauser
78.2514 T26

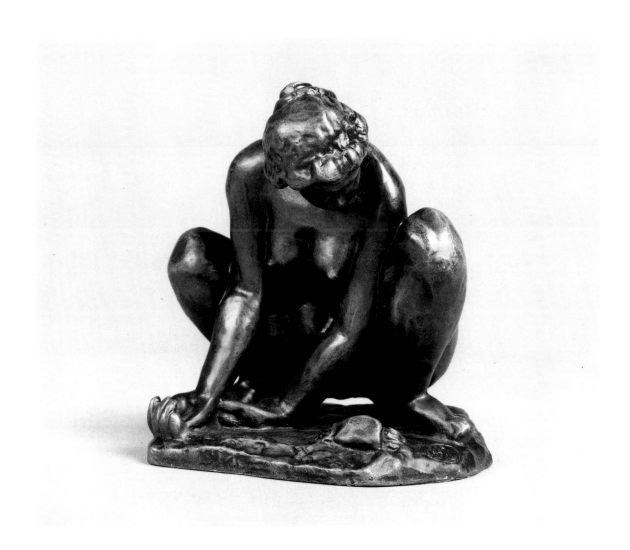

Aristide Maillol

5 *Pomona with Lowered Arms (Pomone aux bras tombants).* Late 1920s
 Bronze, 65¾ x 22 x 16 in. (167 x 55.8 x 40.6 cm.)
 58.1513; SRGM hb. 6

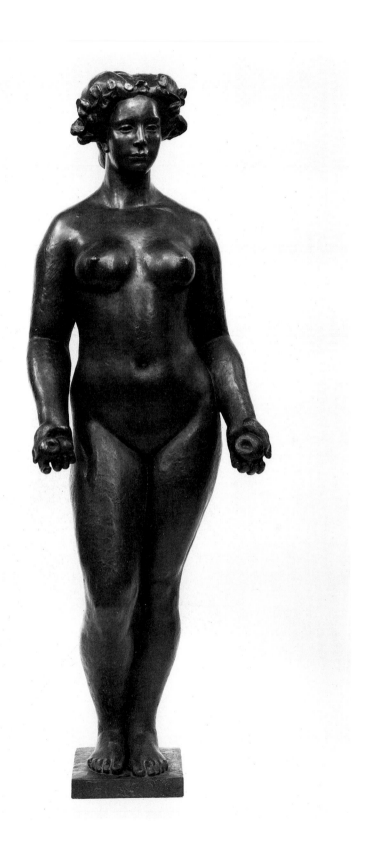

Ernst Barlach

6 *The Reader (Der Buchleser)*. 1936
 Bronze, 18 x 7½ x 11⅞ in. (45.7 x 19 x 30.4 cm.)
 Gift, B. Gerald Cantor Art Foundation
 83.2985

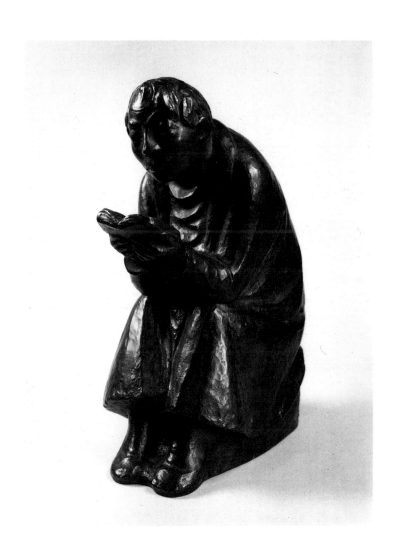

Raymond Duchamp-Villon

7 *Maggy (Tête de Maggy).* 1912
 Bronze, 29⅛ x 13⅛ x 16 in. (74 x 87.9 x 40.6 cm.)
 57.1464; SRGM hb. 36

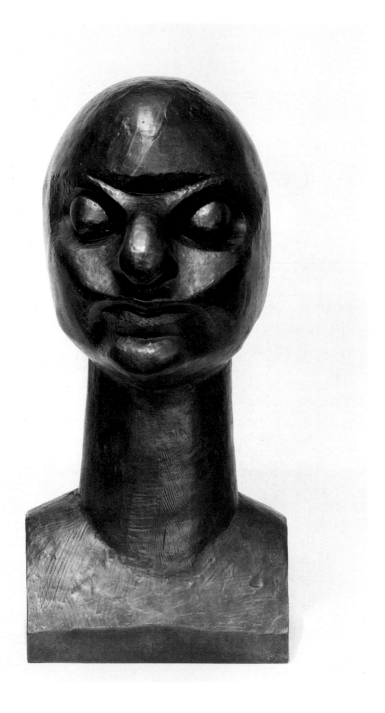

Raymond Duchamp-Villon

8 *The Horse (Le Cheval)*. 1914 (cast ca. 1930)
Bronze, 17³⁄₁₆ x 16⅛ in. (43.6 x 41 cm.)
Peggy Guggenheim Collection, Venice, The Solomon R. Guggenheim
Foundation
76.2553 PG 24; PGC cat. 50; PGC hb. 15

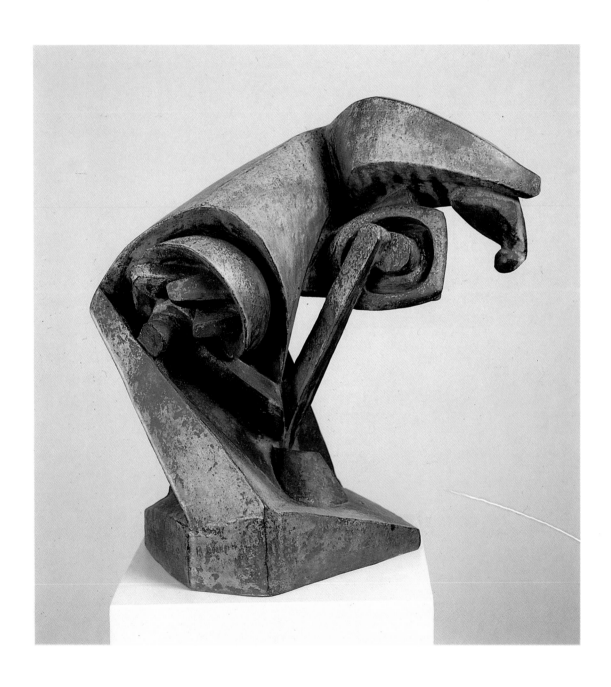

Alexander Archipenko

9 *Médrano II.* 1913
 Painted tin, wood, glass and painted oilcloth, 49⅞ x 20¼ x 12½ in.
 (126.6 x 51.5 x 31.7 cm.)
 56.1445; SRGM hb. 102

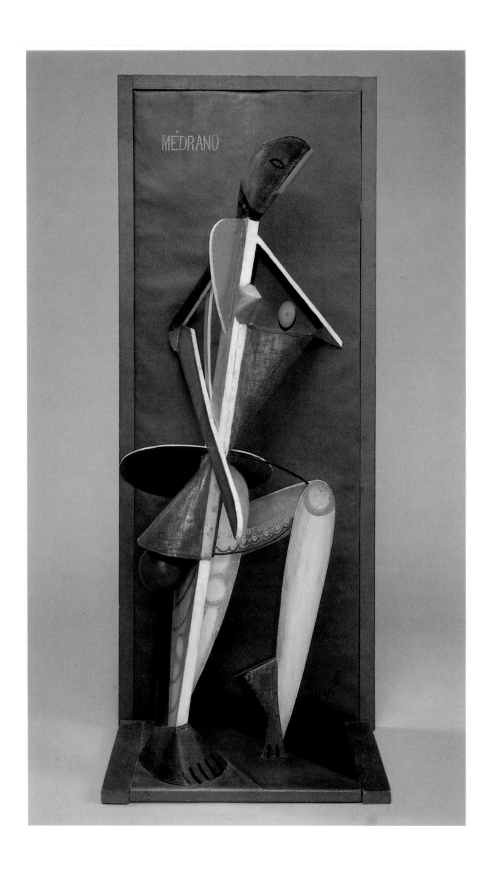

Alexander Archipenko

10 *Carrousel Pierrot.* 1913
Painted plaster, 23⅝ in. (60 cm.) high
57.1483; SRGM hb. 101

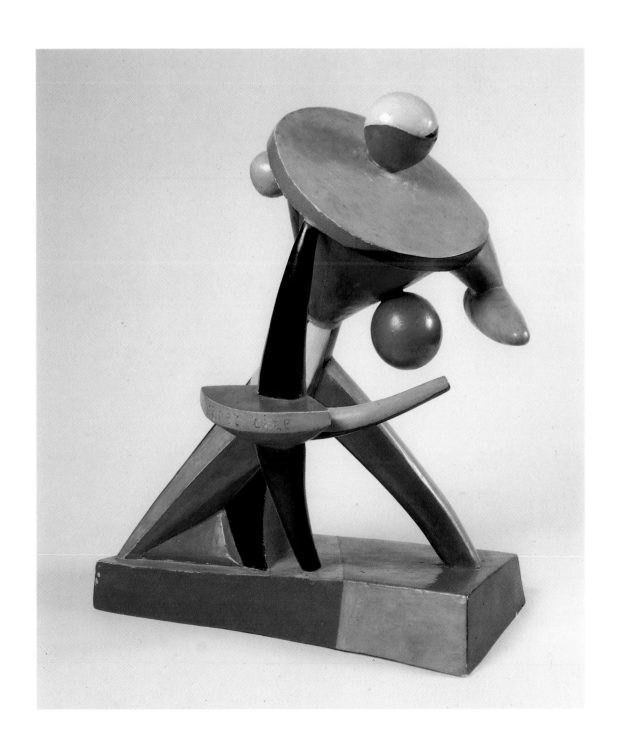

Alexander Archipenko

11 *Boxing (La Boxe)*. 1913–14
 Painted plaster, 23¾ in. (60.4 cm.) high
 55.1436

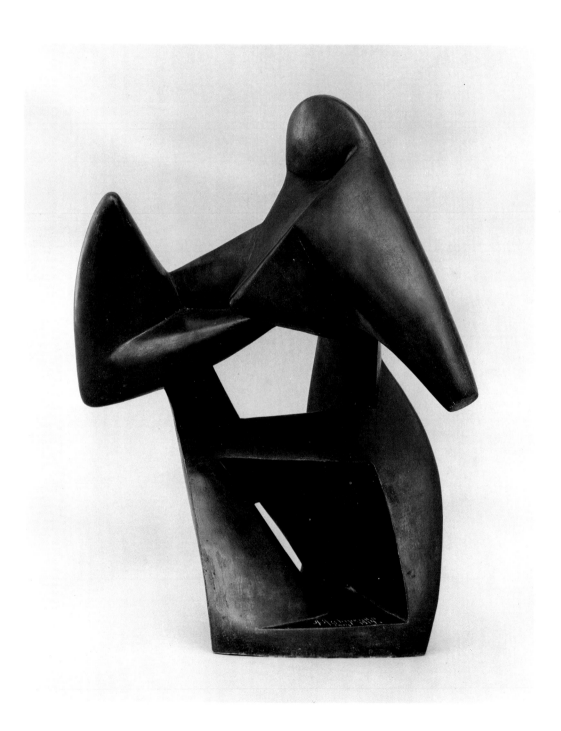

Alexander Archipenko

12 *Vase Woman II.* 1919
Bronze, 22⅝ x 3⅝ x 3⅞ in. (57.4 x 9.2 x 10.3 cm.)
Gift, Estate of Katherine S. Dreier
53.1331

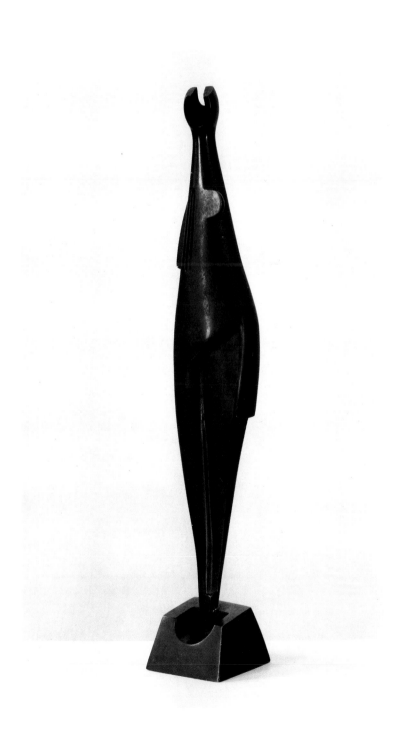

Otto Gutfreund

13 *Embracing Figures*. 1913
Plaster with blue patina, 25⅝ x 13⅛ x 9¾ in. (65.1 x 33.2 x 24.7 cm.)
87.3511

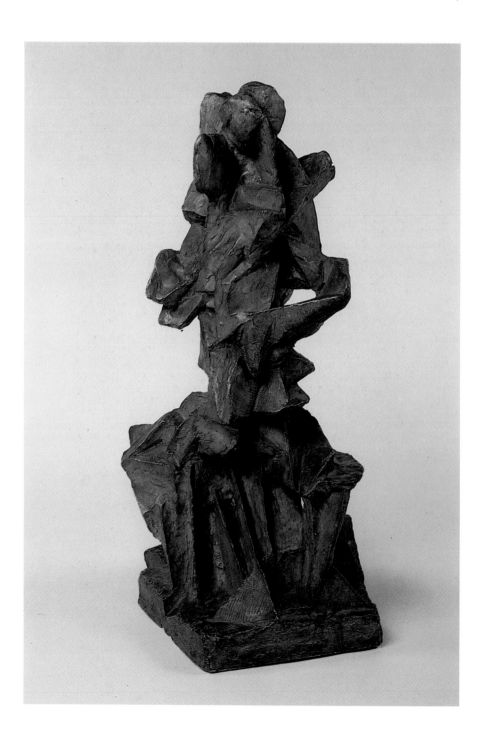

Jacques Lipchitz

14 *Standing Personage (Personnage debout).* 1916
Limestone, 42½ in. (108 cm.) high
58.1526; SRGM hb. 103

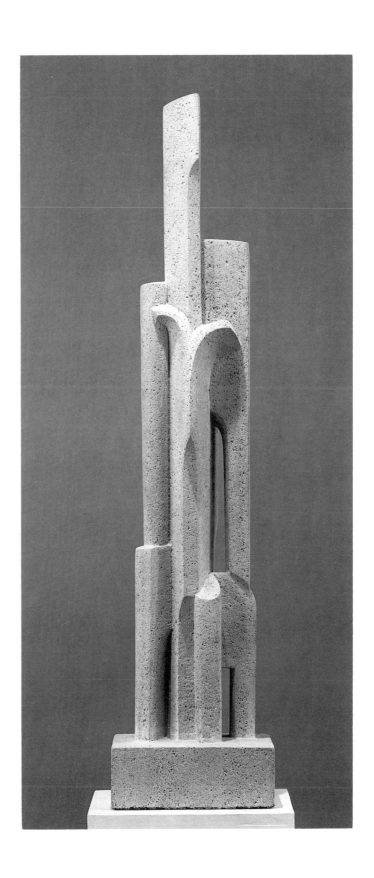

Jacques Lipchitz

15 *Seated Pierrot (Pierrot assis).* 1922
 Lead, 13⁵⁄₁₆ in. (33.5 cm.) high
 Peggy Guggenheim Collection, Venice, The Solomon R. Guggenheim
 Foundation
 76.2553 PG 28; PGC cat. 98; PGC hb. 17

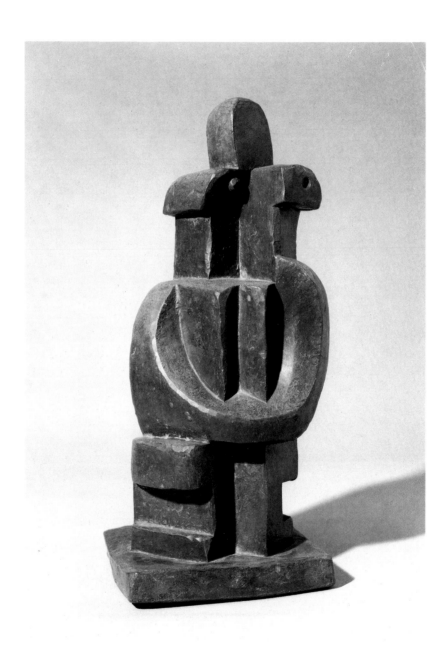

Henri Laurens

16 *Head of a Young Girl (Tête de jeune fillette).* 1920 (cast 1959)
Terra-cotta, 13½ x 6½ in. (34.2 x 16.5 cm.)
Peggy Guggenheim Collection, Venice, The Solomon R. Guggenheim
Foundation
76.2553 PG 27; PGC cat. 95; PGC hb. 16

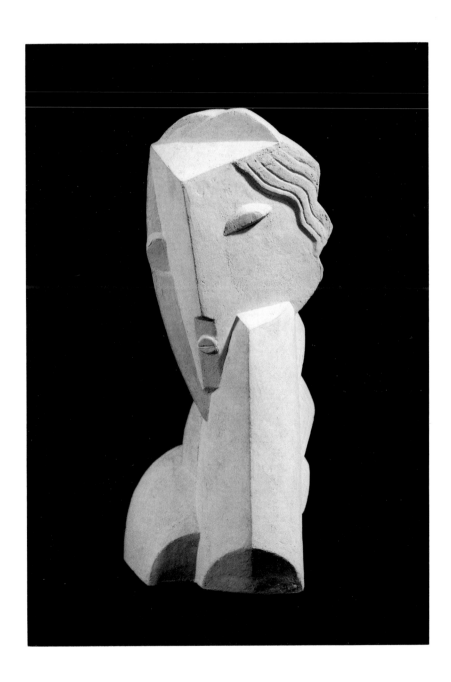

Amedeo Modigliani

17 *Head (Tête)*. 1911–13
 Limestone, 25 in. (63.5 cm.) high
 55.1421; SRGM hb. 96

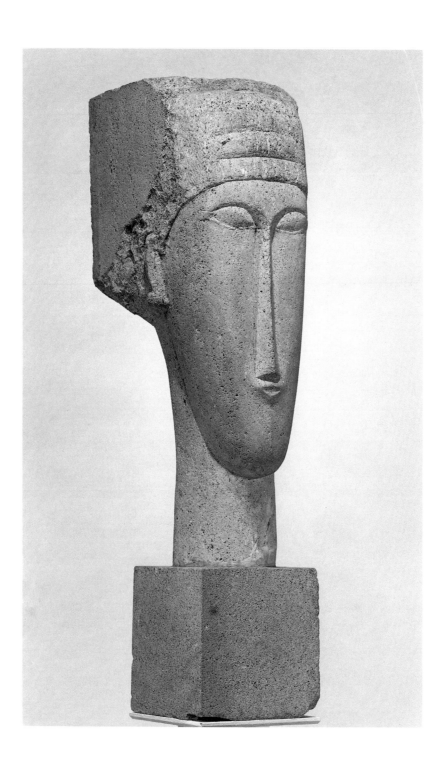

Constantin Brancusi

18 *Portrait of George (Le Portrait de George)*. 1911
 Marble, 9⅜ in. (23.8 cm.) high
 56.1446

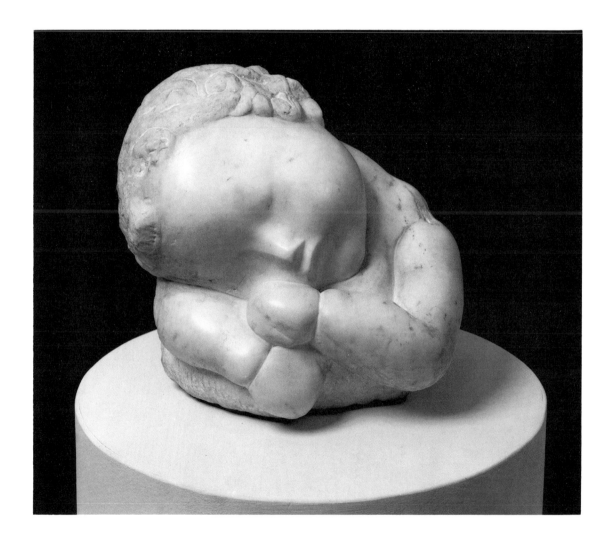

19 *The Muse (La Muse).* 1912
 Marble, 17½ x 9½ x 8 in. (44.5 x 24.1 x 20.3 cm.)
 85.3317

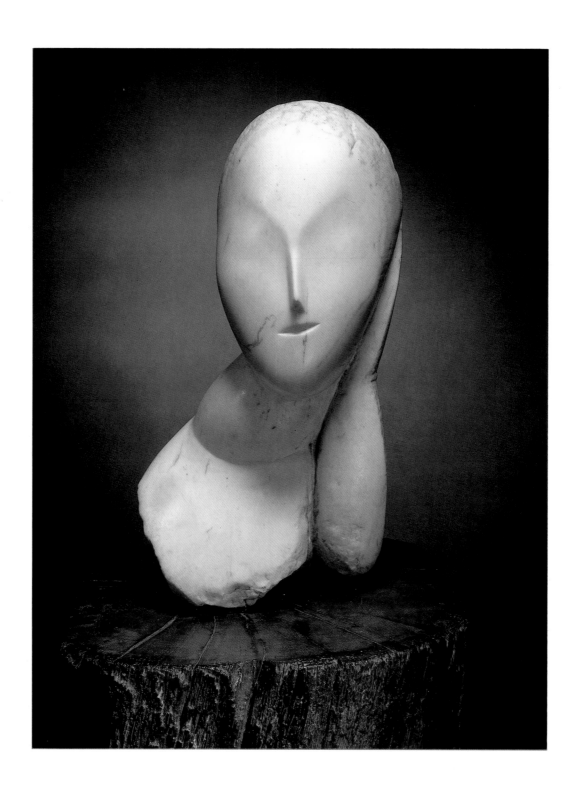

20 *Maiastra*. 1912(?)
Polished brass, 24⅜ in. (62 cm.) high, on stone base, 5⁹⁄₁₆ in. (14.2 cm.) high
Peggy Guggenheim Collection, Venice, The Solomon R. Guggenheim
Foundation
76.2553 PG 50; PGC cat. 17; PGC hb. 43

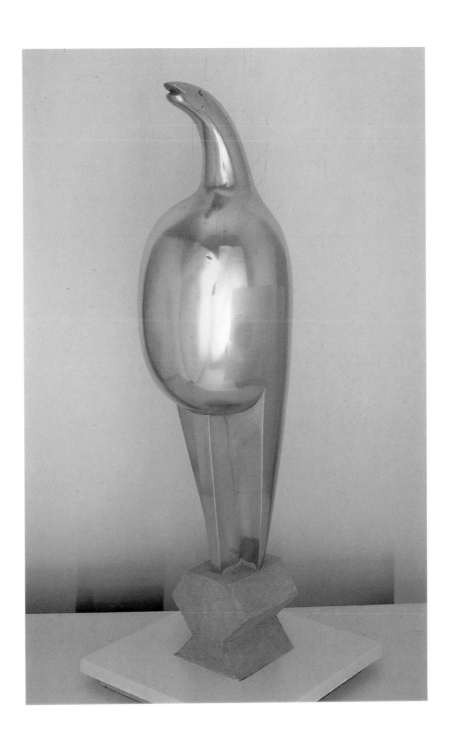

Constantin Brancusi

21 *The Sorceress (La Sorcière)*. 1916–24
 Wood, 39⅜ in. (100 cm.) high
 56.1448; SRGM hb. 91

Constantin Brancusi

22 *Adam and Eve (Adam et Eve)*. 1916–21
 Oak and chestnut, *Eve* (oak), 46¼ in. (118.1 cm.) high, *Adam* (chestnut),
 34⅞ in. (88.6 cm.) high, on limestone base, 12½ in. (31.7 cm.) high; total
 94¼ in. (239.4 cm.) high
 53.1329.a–.d; SRGM hb. 92

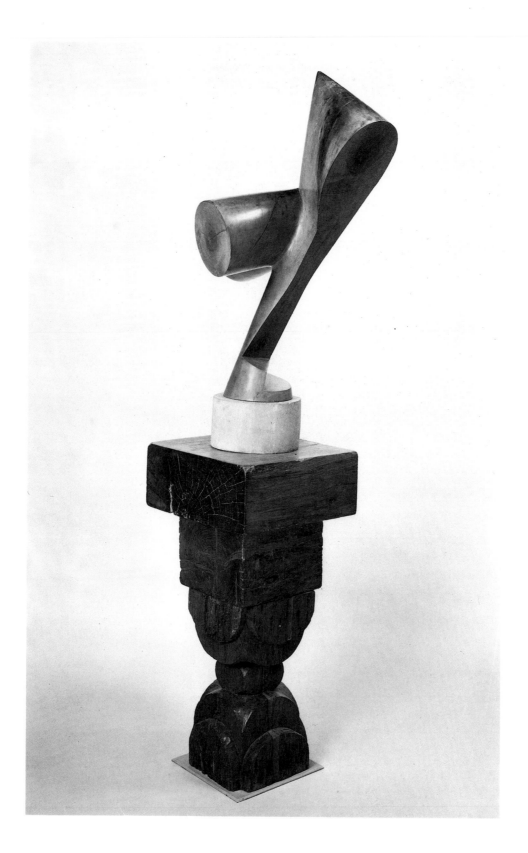

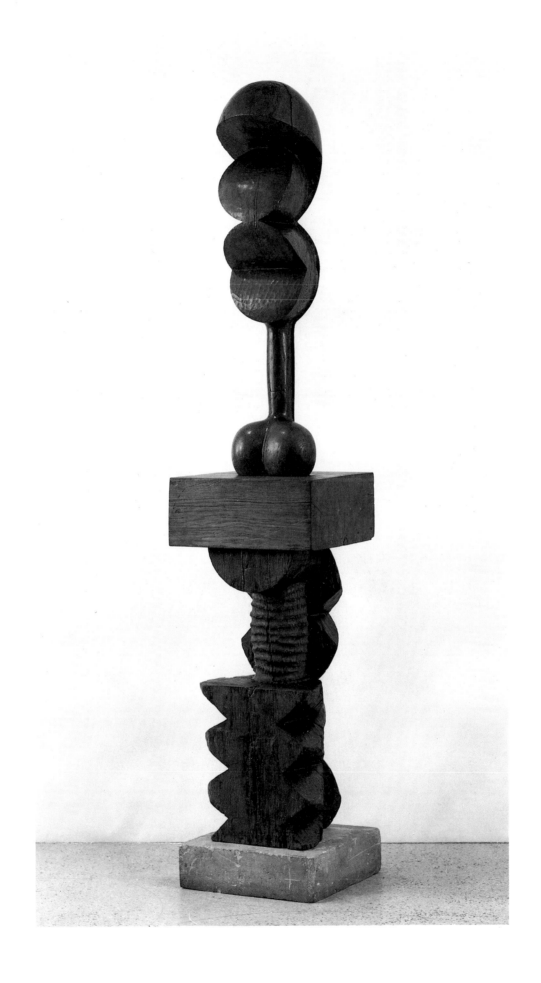

Constantin Brancusi

23 *Little French Girl (La Jeune Fille française).* ca. 1914–18
 Oak, 49 in. (124.5 cm.) high
 Gift, Estate of Katherine S. Dreier
 53.1332

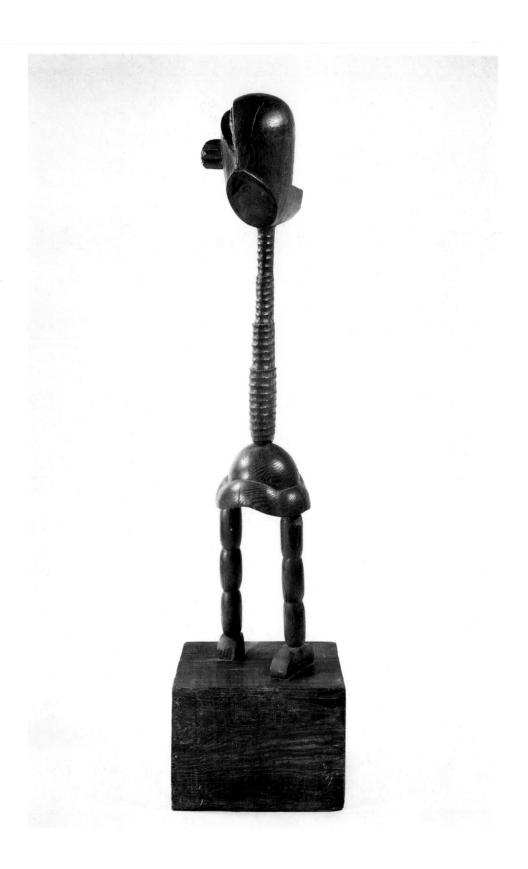

Constantin Brancusi

24 *The Seal (Miracle) (Le Miracle).* 1924–36
 Marble, 42¾ x 44⅞ x 13 in. (108.6 x 114 x 33 cm.)
 56.1450; SRGM hb. 95

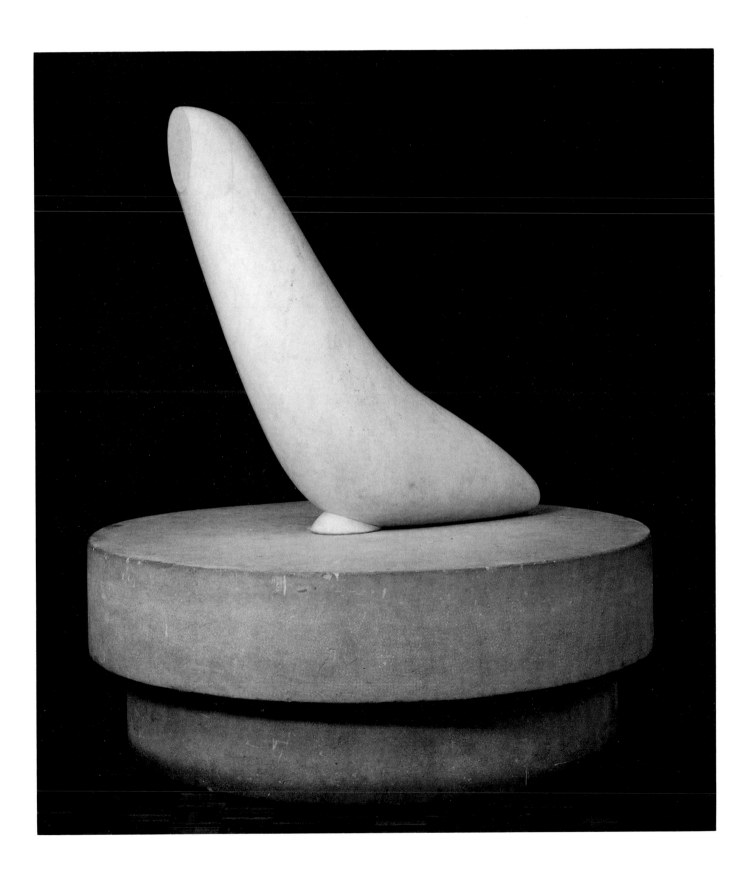

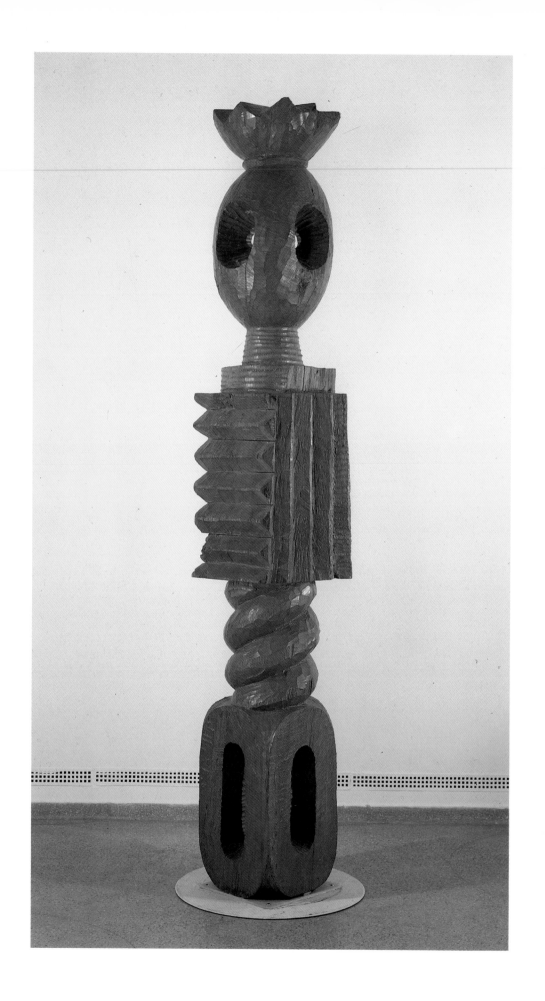

Constantin Brancusi

25 *King of Kings (Le Roi des rois).* Early 1930s
 Oak, 118⅛ in. (300 cm.) high
 56.1449; SRGM hb. 94

Constantin Brancusi

26 *Bird in Space (L'Oiseau dans l'espace).* 1932–40
 Polished brass, 53 in. (134.7 cm.) high
 Peggy Guggenheim Collection, Venice, The Solomon R. Guggenheim
 Foundation
 76.2553 PG 51; PGC cat. 18; PGC hb. 44

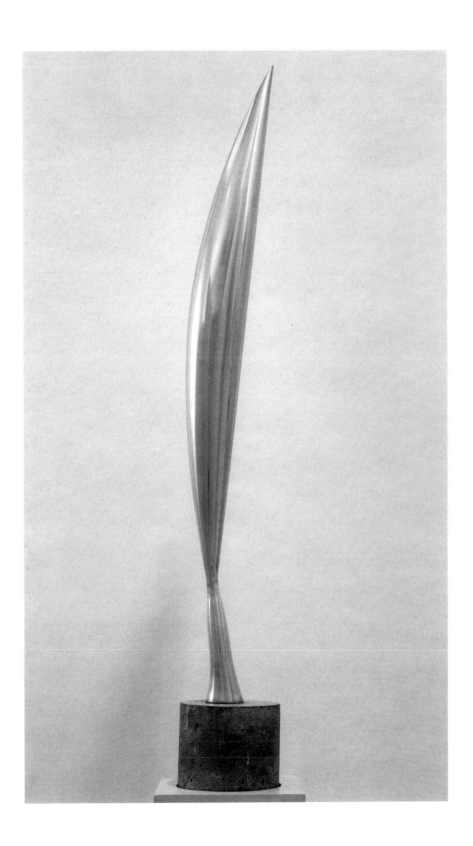

Constantin Brancusi

27 *Flying Turtle (Tortue volante)*. 1940–45
Marble, 12½ x 36⅝ x 27⅛ in. (31.8 x 93 x 69 cm.)
55.1451

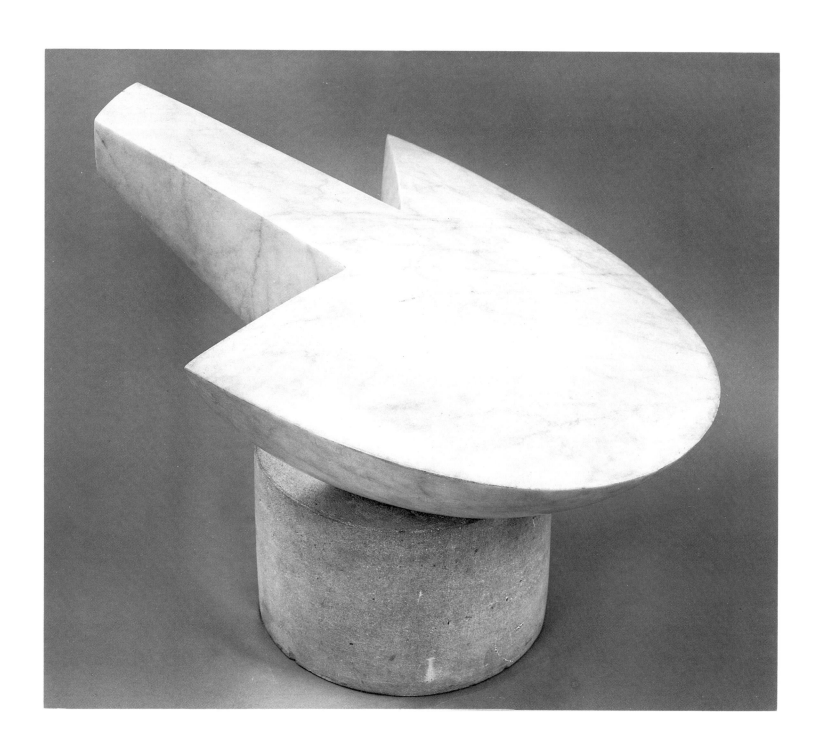

Jean Arp

28 *Overturned Blue Shoe with Two Heels Under a Black Vault (Soulier bleu*
renversé à deux talons, sous une voûte noire). ca. 1925
Painted wood, 31¼ x 41⅛ x 2 in. (79.3 x 104.6 x 5 cm.)
Peggy Guggenheim Collection, Venice, The Solomon R. Guggenheim
Foundation
76.2553 PG 53; PGC cat. 5; PGC hb. 65

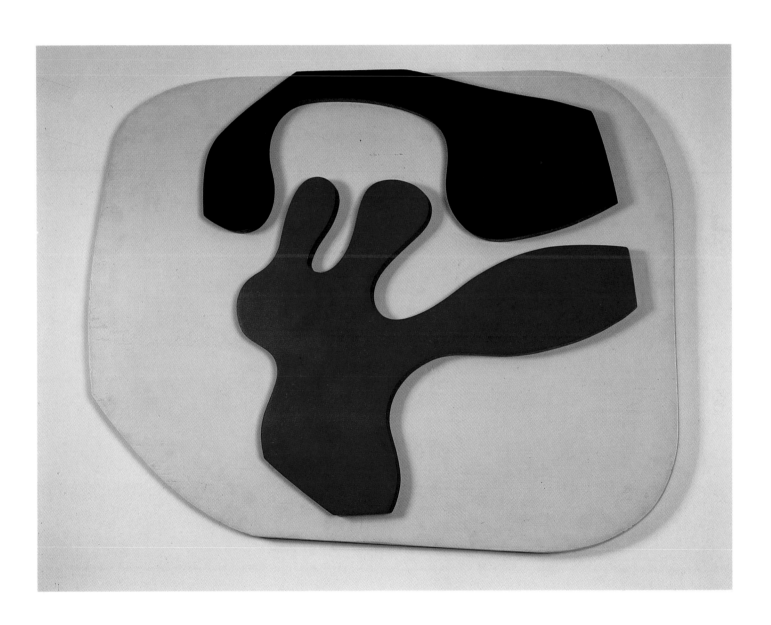

Jean Arp

29 *Head and Shell (Tête et coquille).* ca. 1933
 Polished brass, 2 parts, total 7¾ x 8⅞ in. (19.7 x 22.5 cm.)
 Peggy Guggenheim Collection, Venice, The Solomon R. Guggenheim
 Foundation
 76.2553 PG 54; PGC cat. 6; PGC hb. 66

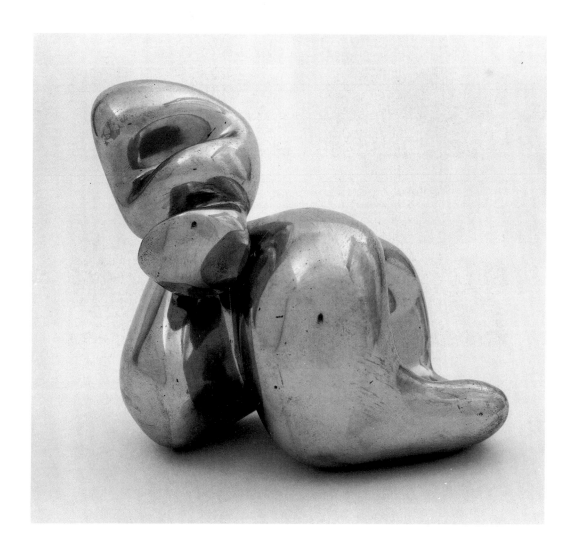

Jean Arp

30 *Growth (Croissance)*. 1938
 Marble, 31⅝ in. (80.3 cm.) high
 53.1359; SRGM hb. 129

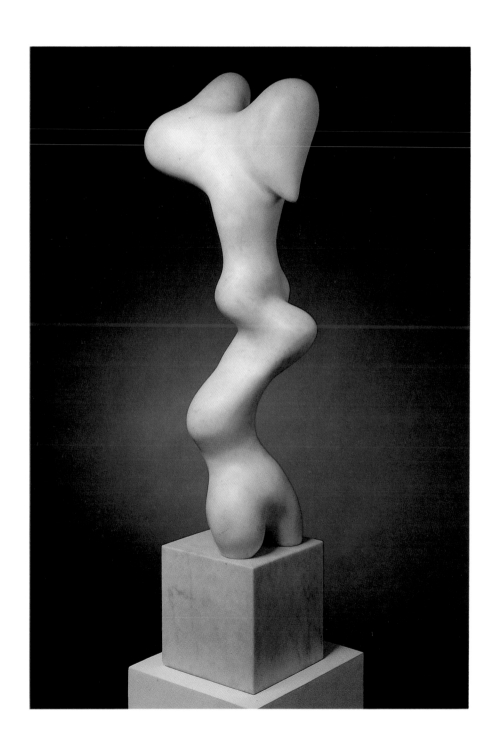

Jean Arp

31 *Shell-Crystal (Coquille-cristal)*. 1938
 Plaster, 11 x 15 x 15½ in. (27.9 x 38.1 x 39.4 cm.)
 Gift, Mrs. Jean Arp
 76.2221

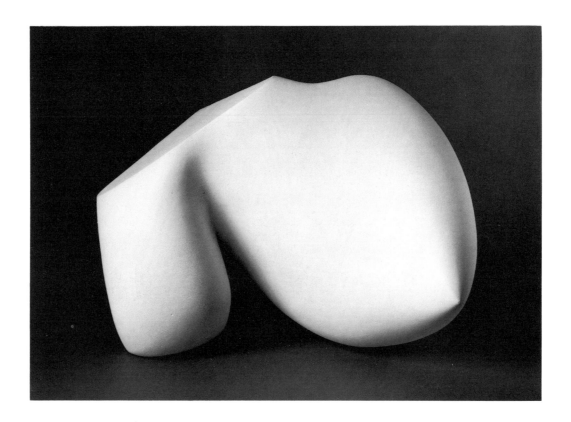

Jean Arp

32 *Amphora-Fruit (Fruit-amphore).* 1946(?) (cast 1951)
Bronze, 29³⁄₈ x 38¹⁵⁄₁₆ in. (74.5 x 99 cm.)
Peggy Guggenheim Collection, Venice, The Solomon R. Guggenheim
Foundation
76.2553 PG 58; PGC cat. 10; PGC hb. 68

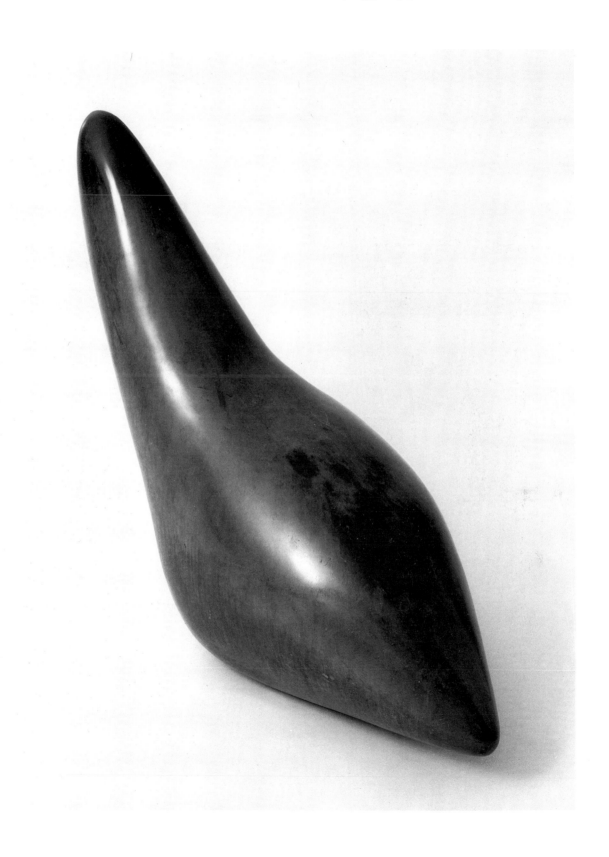

Jean Arp

33 *Classical Sculpture (Sculpture classique)*. 1960–63
Plaster, 48 x 8½ x 6 in. (121.9 x 21.6 x 15.3 cm.)
Gift, Mrs. Jean Arp
76.2223

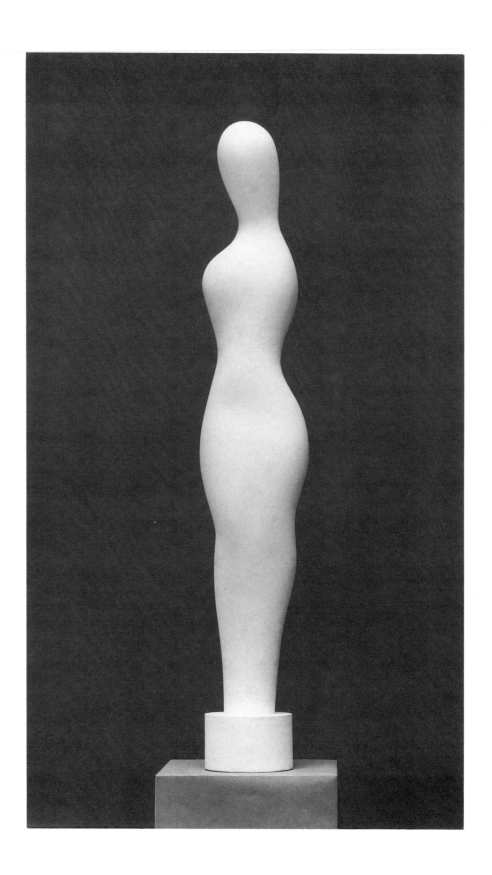

Naum Gabo

34 *Column.* ca. 1923 (reconstructed 1937)
Perspex, wood, metal and glass, 41½ x 29 x 29 in. (105.3 x 73.6 x 73.6 cm.)
55.1429; SRGM hb. 118

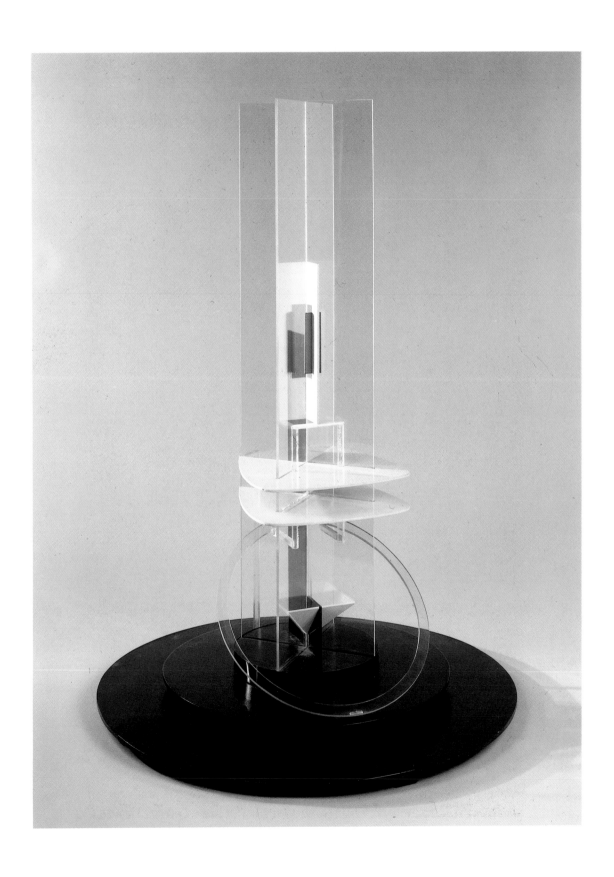

Naum Gabo

35 *Construction in Space "Arch."* 1937
 Plastic, 18¾ x 31½ x 9½ in. (47.5 x 80 x 24.1 cm.)
 47.1103

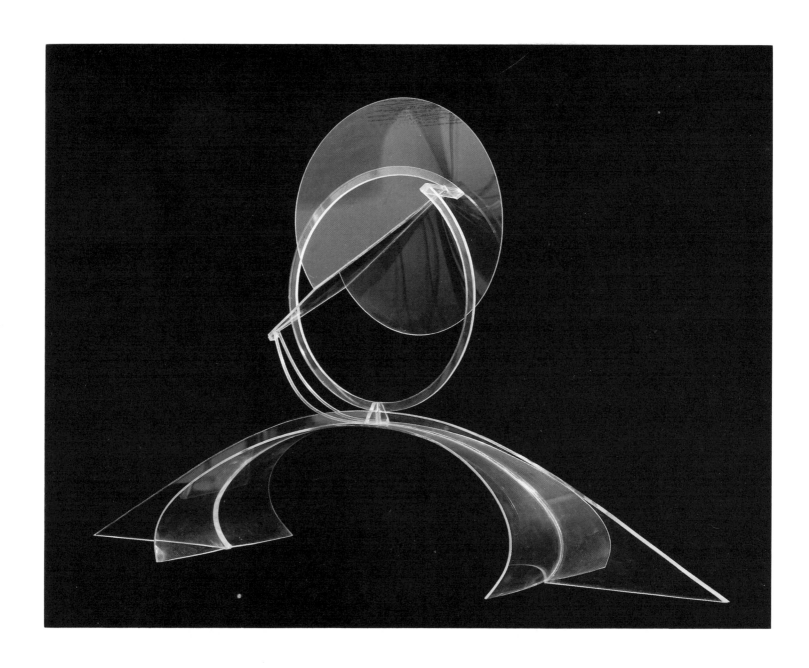

Naum Gabo

36 *Construction on a Plane.* 1937–39
 Plastic, 18⅞ x 18⅞ x 9¼ in. (48 x 48 x 23.5 cm.)
 47.1102

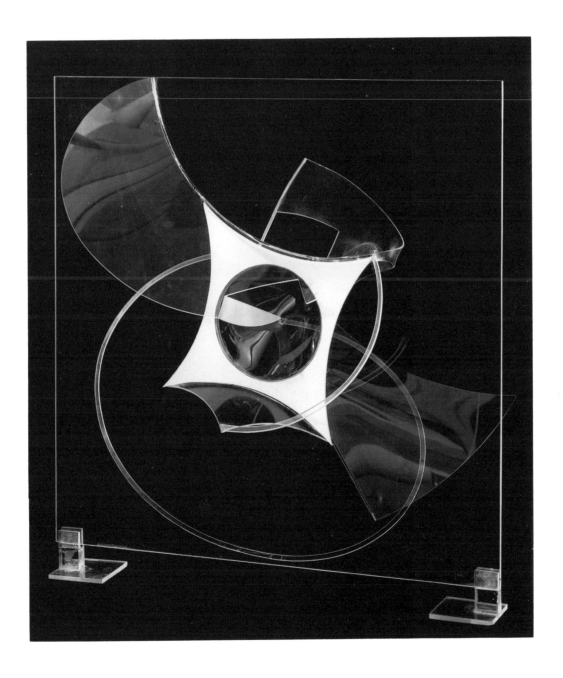

Naum Gabo

37 *Linear Construction in Space No. 1.* 1942–43
 Plexiglass and nylon monofilament, 18 x 17¾ x 3³⁄₁₆ in. (45.7 x 45.1 x 8.1 cm.)
 47.1101; SRGM hb. 119

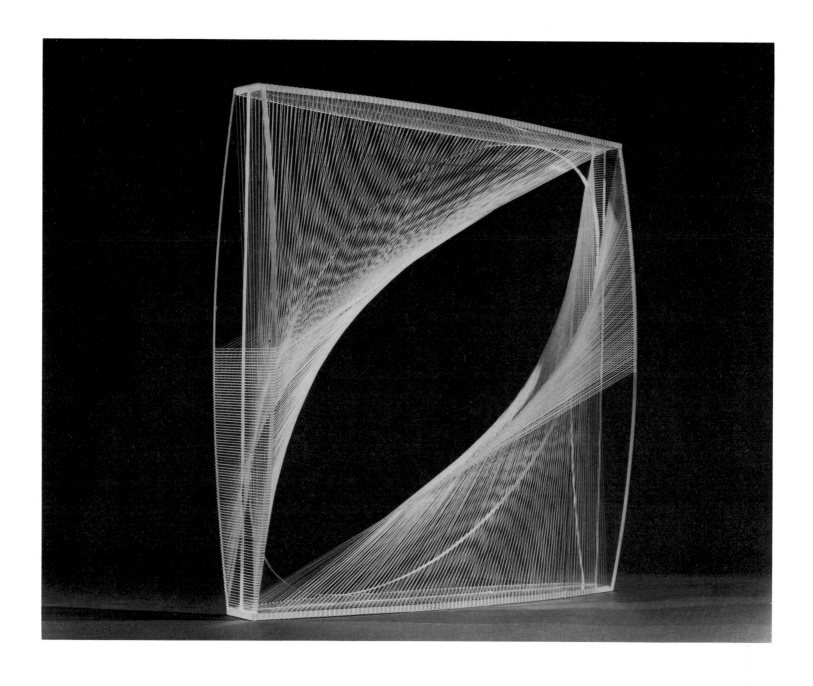

Naum Gabo

38 *Linear Construction in Space No. 2.* ca. 1957–58
 Plexiglass and nylon monofilament, 8 x 14½ x 8 in. (20.3 x 36.8 x 20.3 cm.)
 Gift, Mr. and Mrs. Marcel Breuer
 78.2455

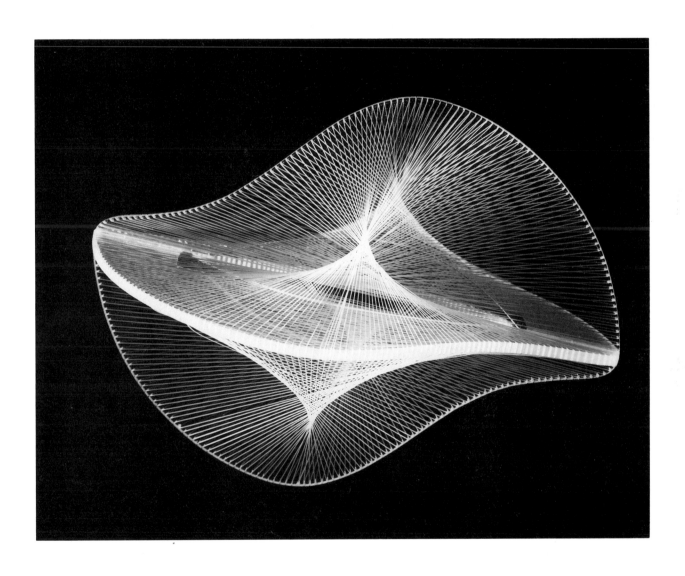

Naum Gabo

39 *Translucent Variation on Spheric Theme.* 1937 (reconstructed 1951)
 Plastic, 22⅜ x 17⅝ x 17⅝ in. (56.8 x 44.8 x 44.8 cm.)
 48.1174

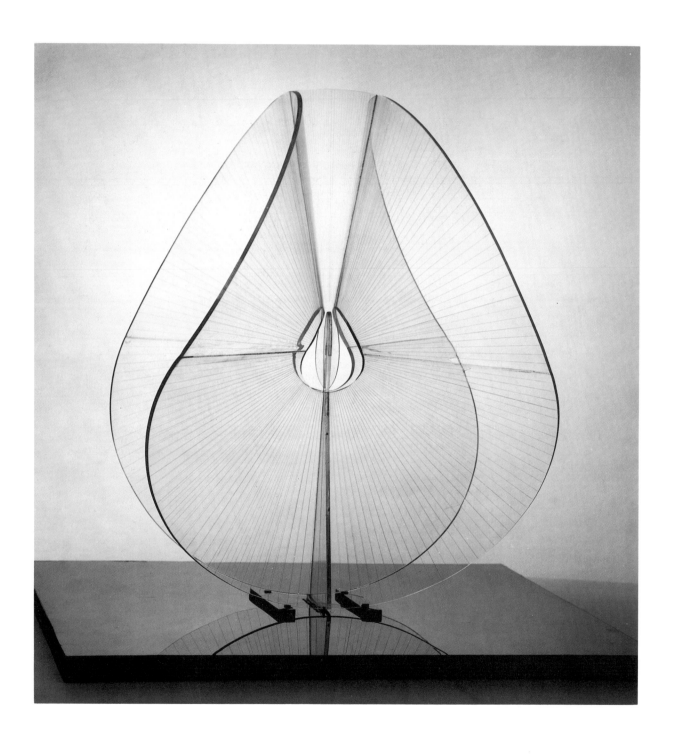

Antoine Pevsner

40 *Developable Surface (Surface développable).* 1941
Bronze and silver plate, 21⅝ x 14¼ x 19⁵⁄₁₆ in. (55 x 36.3 x 49.1 cm.)
Peggy Guggenheim Collection, Venice, The Solomon R. Guggenheim
Foundation
76.2553 PG 62; PGC cat. 135; PGC hb. 33

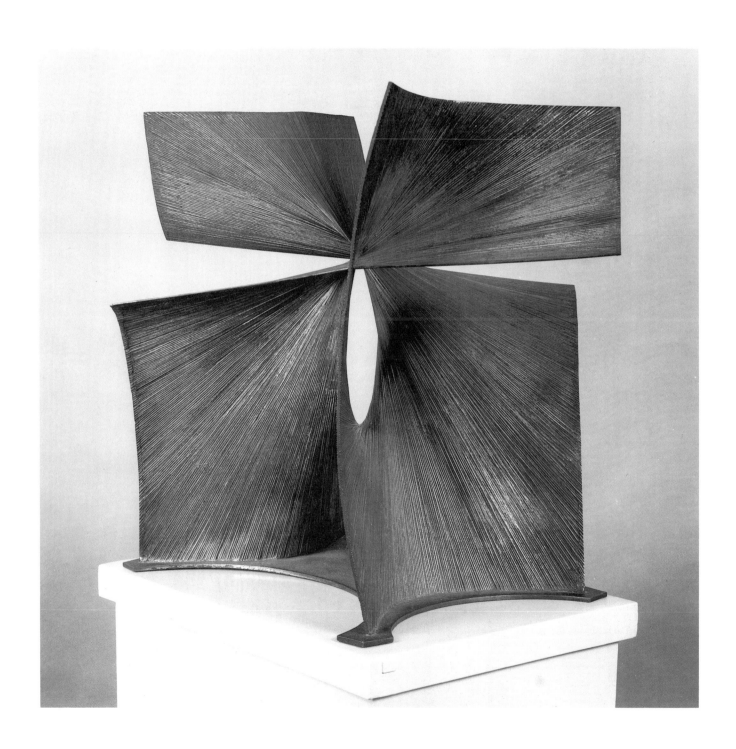

Antoine Pevsner

41 *Twinned Column (Colonne jumelée)*. 1947
 Bronze, 40½ x 14 x 14 in. (102.9 x 36 x 36 cm.)
 54.1397; SRGM hb. 120

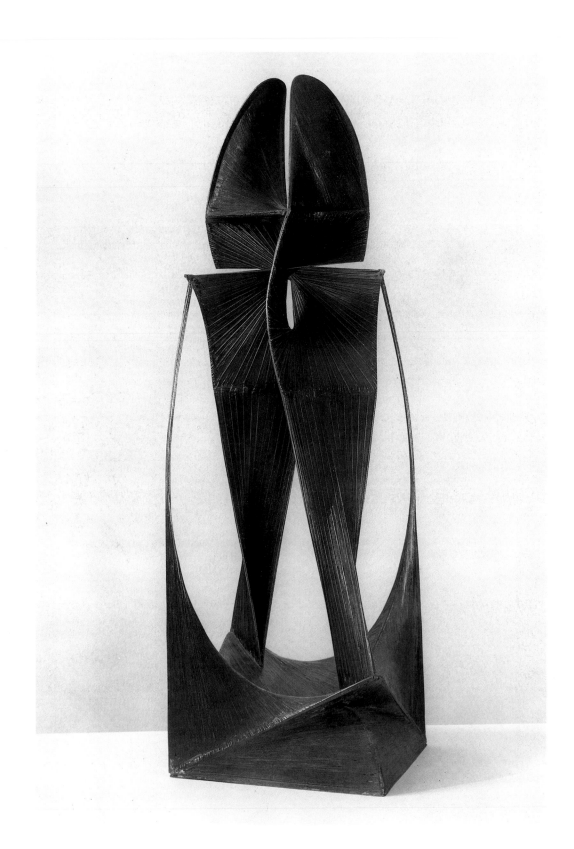

László Moholy-Nagy

42 *Dual Form with Chromium Rods*. 1946
 Plexiglass and chrome-plated steel rods, 36½ x 47⅞ x 22 in. (92.7 x
 121.6 x 55.9 cm.)
 48.1149; SRGM hb. 123

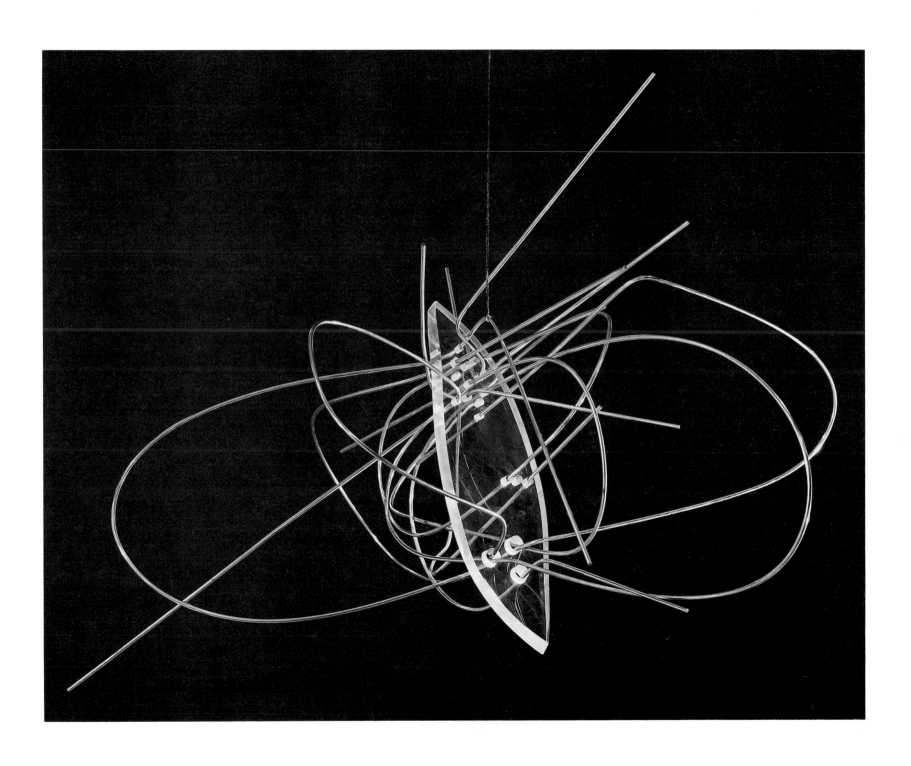

Julio González

43 *Little Mask (Petite Masque)*. 1935
 Bronze, 7½ x 3⅜ x 2½ in. (19 x 8.6 x 6.4 cm.), on stone base, 1¾ x 2⅝ x
 3⅜ in. (4.5 x 6.6 x 8.6 cm.)
 Gift, Mrs. Andrew P. Fuller
 66.1808

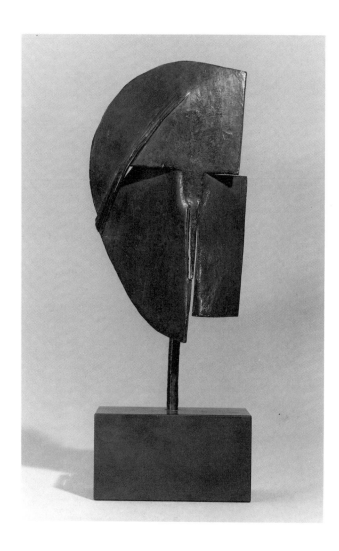

Julio González

44 *Small Sickle (Figure of a Woman) (Petite Faucille [Femme debout])*. ca. 1937
Forged bronze, 13¾ x 4½ x 3⅝ in. (34.9 x 11.4 x 9.2 cm.), on limestone
base, 2½ x 4 x 3½ in. (6.3 x 10.2 x 8.9 cm.)
Gift, Mr. and Mrs. Irving Moskovitz
83.3079

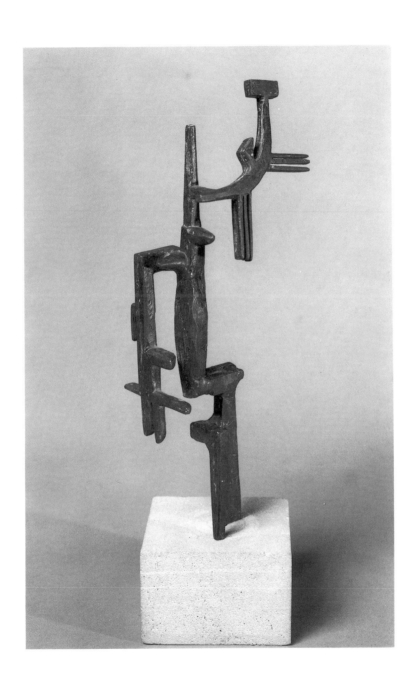

Julio González

45 *"Monsieur" Cactus (Cactus Man I) ("Monsieur" Cactus [L'Homme Cactus I]).* 1939 (cast 1953–54)
Bronze, 23⁵⁄₁₆ x 9¹³⁄₁₆ x 6¹¹⁄₁₆ in. (64.3 x 25 x 17 cm.)
Peggy Guggenheim Collection, Venice, The Solomon R. Guggenheim Foundation
76.2553 PG 136; PGC cat. 72; PGC hb. 75

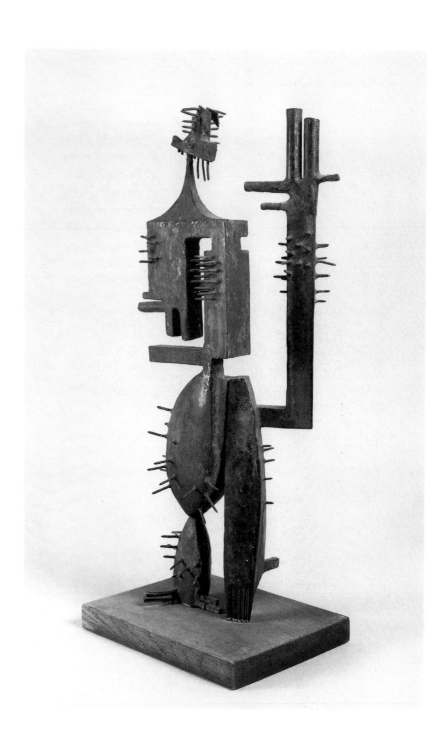

Max Ernst

46 *An Anxious Friend (Un Ami empressé)*. Summer 1944
Bronze, 26⅜ in. (67 cm.) high
Gift, Dominique and John de Menil
59.1521; SRGM hb. 127

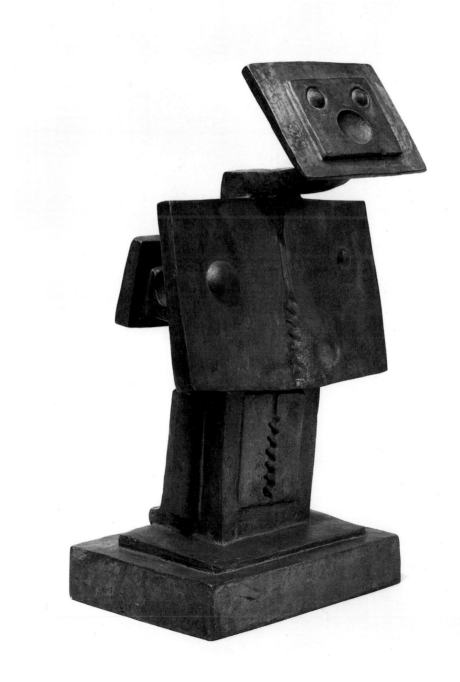

Max Ernst

47 *In the Streets of Athens (Dans les rues d'Athènes).* 1960
 (cast January 1961)
 Bronze, 38¾ x 19⁹⁄₁₆ x 7³⁄₁₆ in. (98.4 x 49.7 x 18.3 cm.)
 Peggy Guggenheim Collection, Venice, The Solomon R. Guggenheim
 Foundation
 76.2553 PG 82; PGC cat. 63; PGC hb. 63

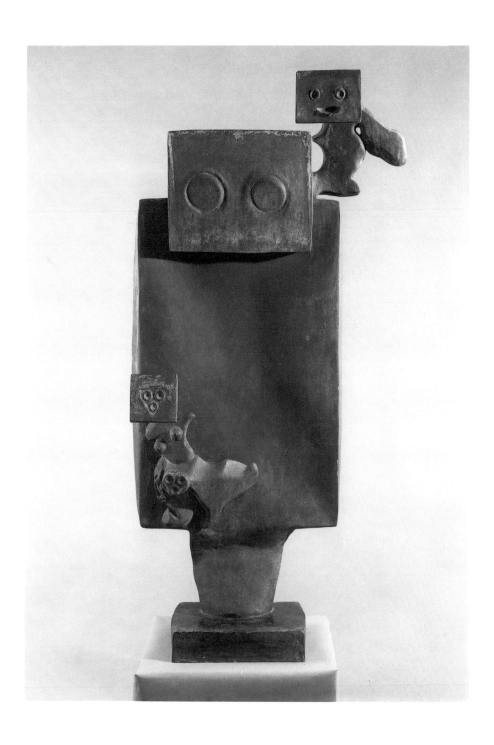

48 *Spoon Woman (Femme-cuiller).* 1926
 Bronze, 57 in. (144.7 cm.) high
 55.1414; SRGM hb. 135

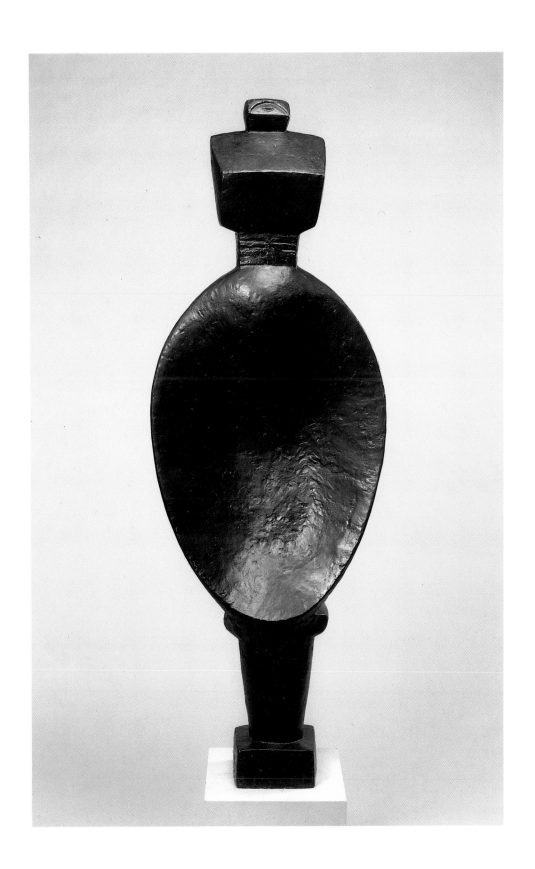

Alberto Giacometti

49 *Model for a Square (Projet pour une place)*. 1931–32
Wood, 7⅝ x 12⅛ x 8⅞ in. (19.4 x 31.4 x 22.5 cm.)
Peggy Guggenheim Collection, Venice, The Solomon R. Guggenheim
Foundation
76.2553 PG 130

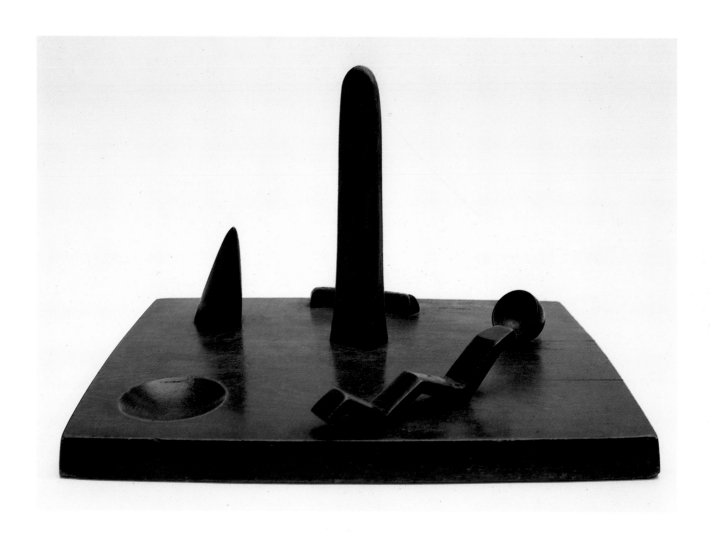

Alberto Giacometti

50 *Woman Walking (Femme qui marche)*. 1932
 Bronze, 56¹⁵⁄₁₆ in. (144.6 cm.) high
 Peggy Guggenheim Collection, Venice, The Solomon R. Guggenheim
 Foundation
 76.2553 PG 133

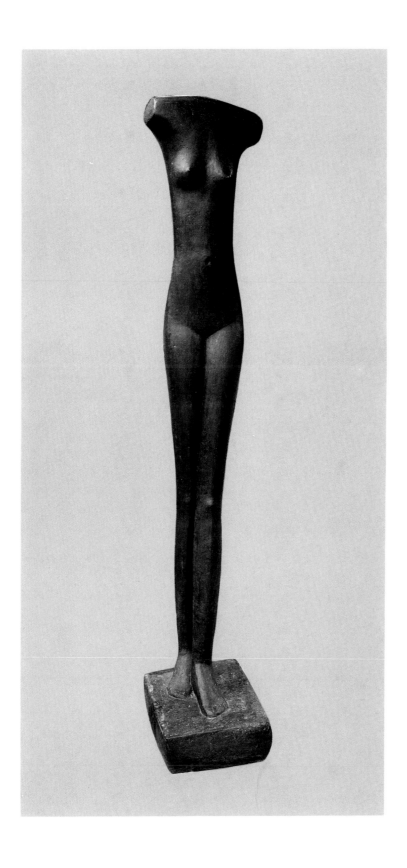

Alberto Giacometti

51 *Woman with Her Throat Cut (Femme égorgée)*. 1932 (cast 1940)
 Bronze, 9⅛ x 35¹⁄₁₆ in. (23.2 x 89 cm.)
 Peggy Guggenheim Collection, Venice, The Solomon R. Guggenheim
 Foundation
 76.2553 PG 131; PGC cat. 68; PGC hb. 77

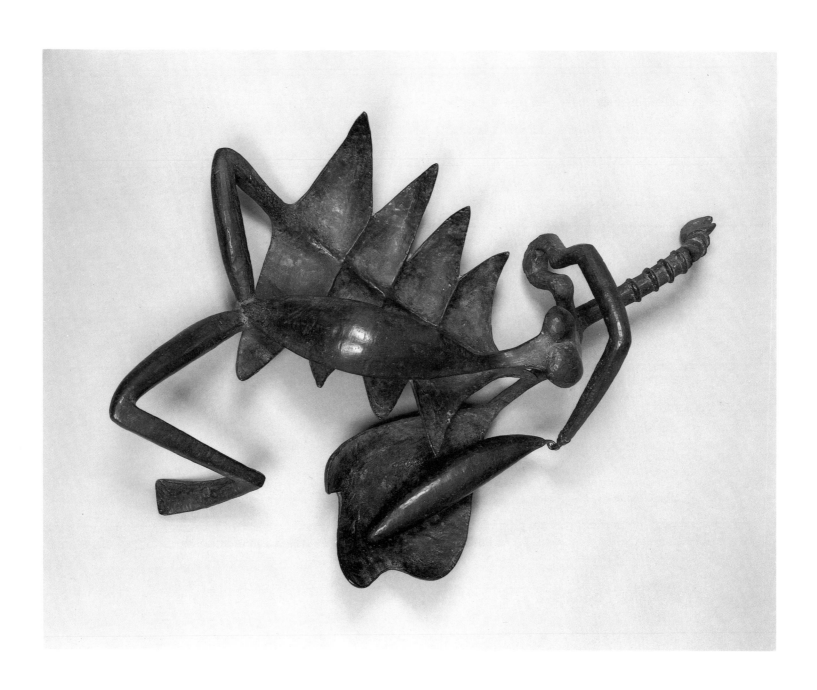

Alberto Giacometti

52 *Nose (Le Nez).* 1947
Bronze, wire, rope and steel, figure, 15⅜ x 3¼ x 26¾ in. (39 x 8.3 x
67.9 cm.), cage, 31¾ x 18½ x 15⅛ in. (80.6 x 47 x 38.4 cm.);
total 31¾ x 26 x 15⅛ in. (80.6 x 66 x 38.4 cm.)
66.1807; SRGM hb. 136

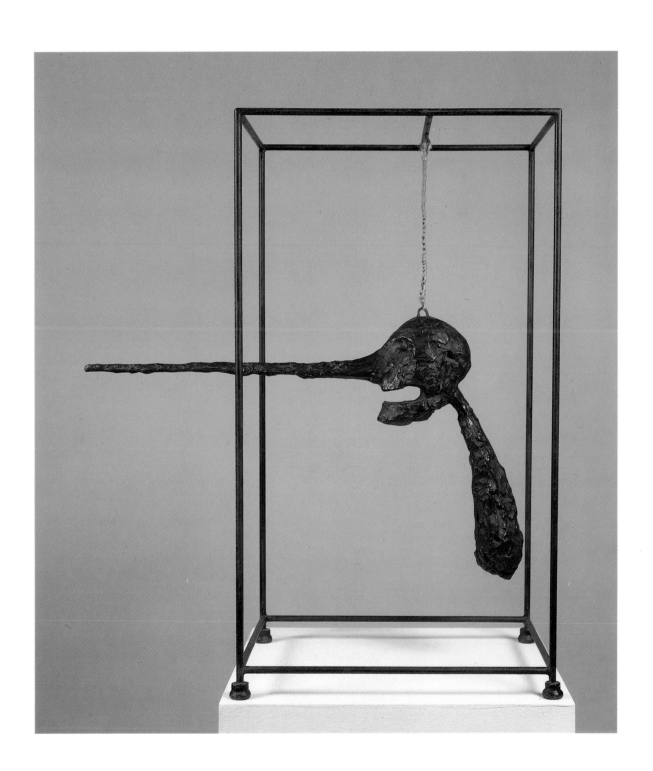

Alberto Giacometti

53　*Standing Woman ("Leoni") (Femme debout ["Leoni"])*. 1947
(cast November 1957)
Bronze, 60¼ in. (153 cm.) high
Peggy Guggenheim Collection, Venice, The Solomon R. Guggenheim
Foundation
76.2553 PG 134; PGC cat. 69; PGC hb. 78

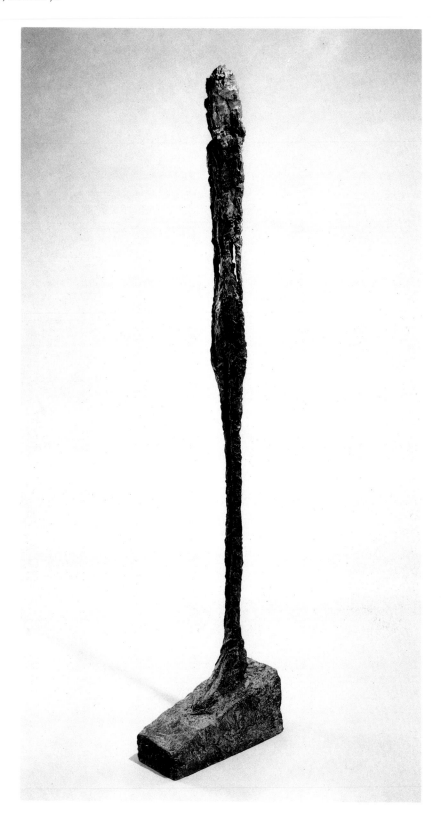

Alberto Giacometti

54 *Piazza*. 1947–48 (cast 1948–49)
Bronze, 8¼ x 24⅝ x 16⅞ in. (21 x 62.5 x 42.8 cm.)
Peggy Guggenheim Collection, Venice, The Solomon R. Guggenheim
Foundation
76.2553 PG 135; PGC cat. 70; PGC hb. 79

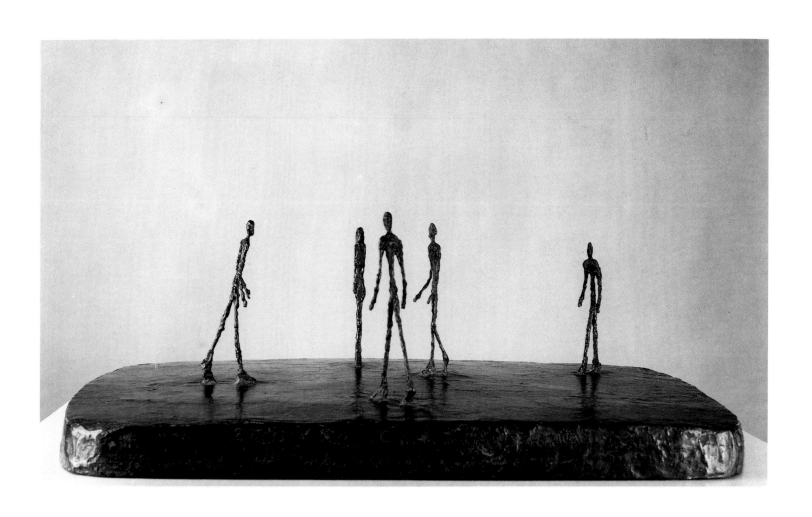

Henry Moore

55 *Three Standing Figures.* 1953
Bronze, 28¾ x 26¼ x 11⅜ in. (73.2 x 68 x 29 cm.)
Peggy Guggenheim Collection, Venice, The Solomon R. Guggenheim
Foundation
76.2553 PG 194; PGC cat. 127; PGC hb. 80

Henry Moore

56 *Upright Figure.* 1956–60
Elm wood, 111 x 41½ x 41 in. (282 x 105.4 x 104.1 cm.)
60.1582; SRGM hb. 142

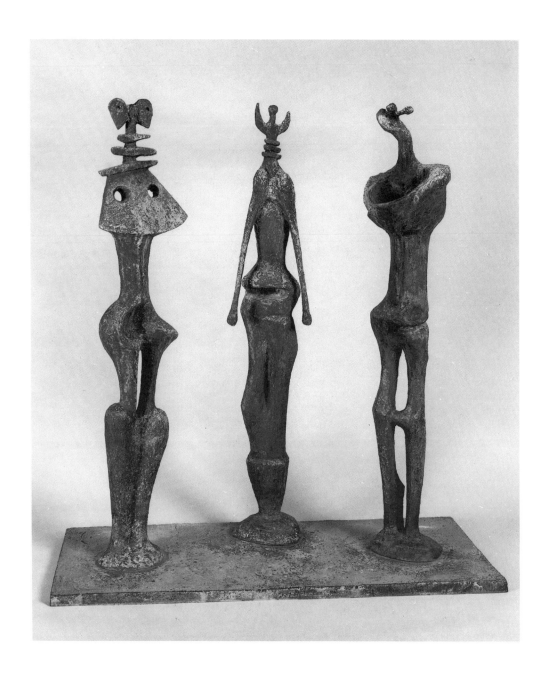

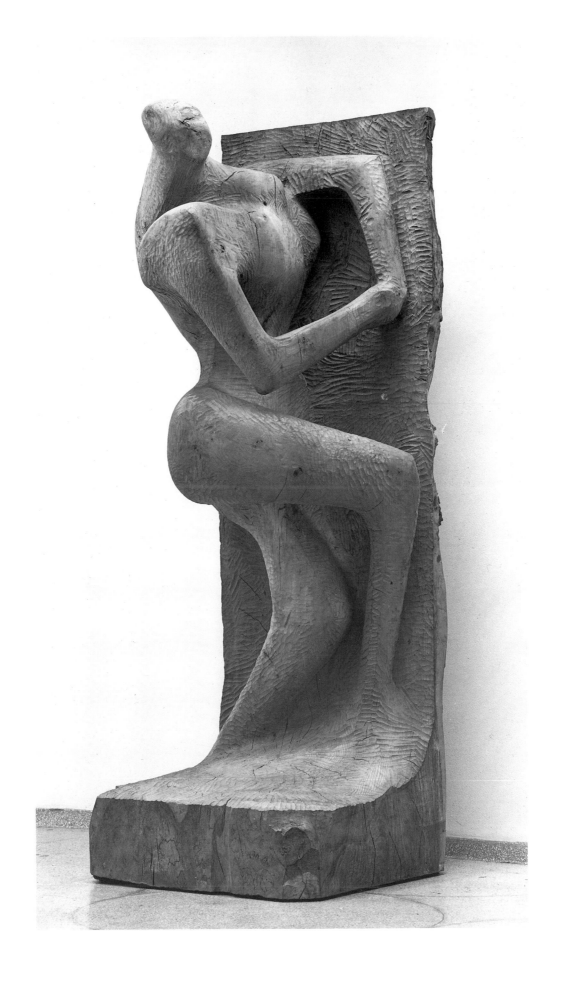

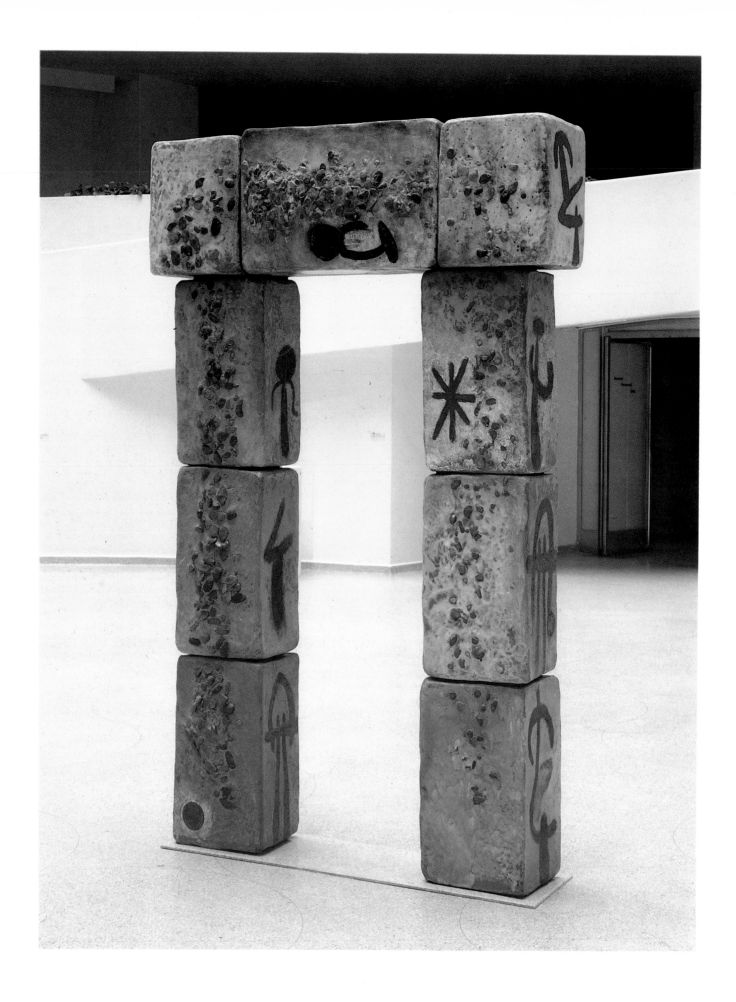

Joan Miró

Executed with Joseph Lloréns Artigas
57 *Portico (Portique)*. April 1956
 Ceramic, 9 parts, total 98 in. (249 cm.) high
 57.1460.a–.i

Joan Miró

Executed with Joseph Lloréns Artigas
58 *Alicia*. 1965–67
 Ceramic tile, 97 x 228½ in. (246.4 x 580.5 cm.)
 Gift, Harry F. Guggenheim in memory of his wife Alicia Patterson
 Guggenheim
 67.1844; SRGM hb. 134

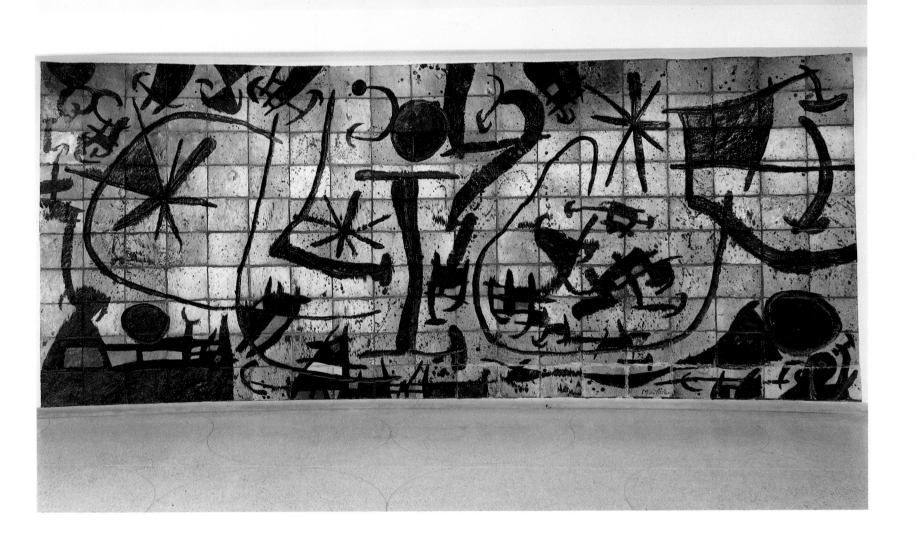

Germaine Richier

59 *Tauromachy (Tauromachie)*. 1953
Bronze, 45¹¹⁄₁₆ x 39³⁄₁₆ x 20⁵⁄₈ in. (116 x 99.5 x 52.5 cm.)
Peggy Guggenheim Collection, Venice, The Solomon R. Guggenheim
Foundation
76.2553 PG 205; PGC cat. 155; PGC hb. 128

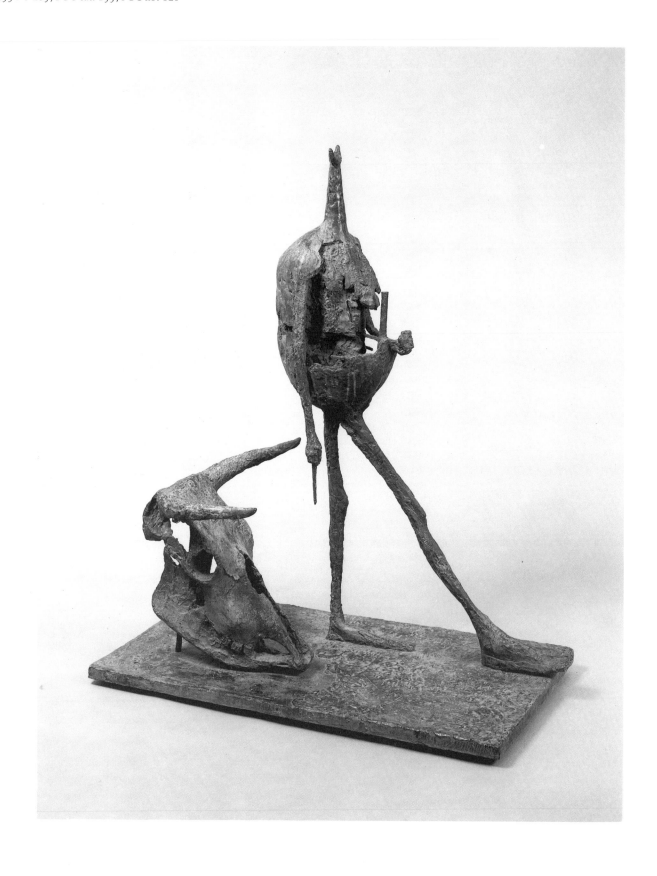

Joseph Beuys

60 *Animal Woman (Tierfrau)*. 1949 (cast 1984)
Bronze, 18⅜ x 5¼ x 4 in. (46.7 x 13.3 x 10 cm.)
85.3256

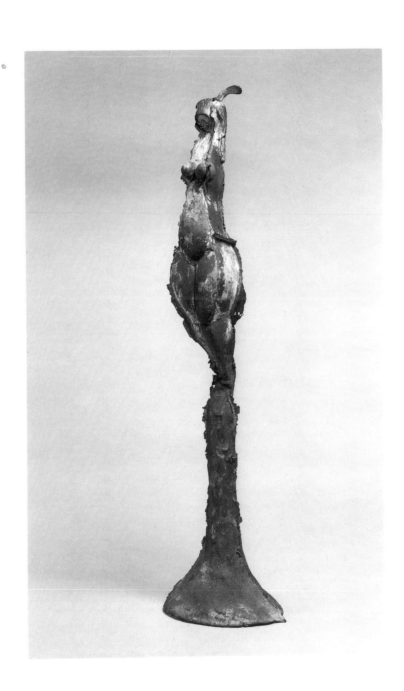

Joseph Beuys

61 *Incontro con Beuys.* 1974–84
 Vitrine containing felt, copper, fat and cord, 75 x 78⅝ x 23½ in. (190.5 x
 199.7 x 59.7 cm.)
 Purchase, The Gerald E. Scofield Bequest

 87.3522.a–.h

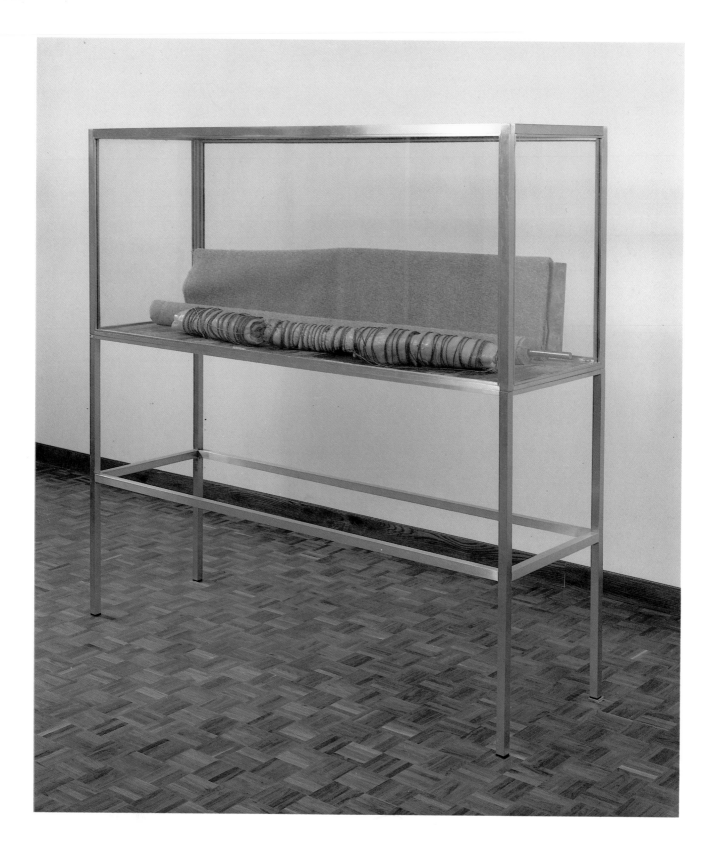

Joseph Beuys

62 *F.I.U. Difesa della Natura*. 1983–85
Automobile, shovels, copper, pamphlets and blackboards, dimensions
according to installation
85.3315.a, .b.1–.13, .c.1–.21, .d.1–.159, .e.1, .2

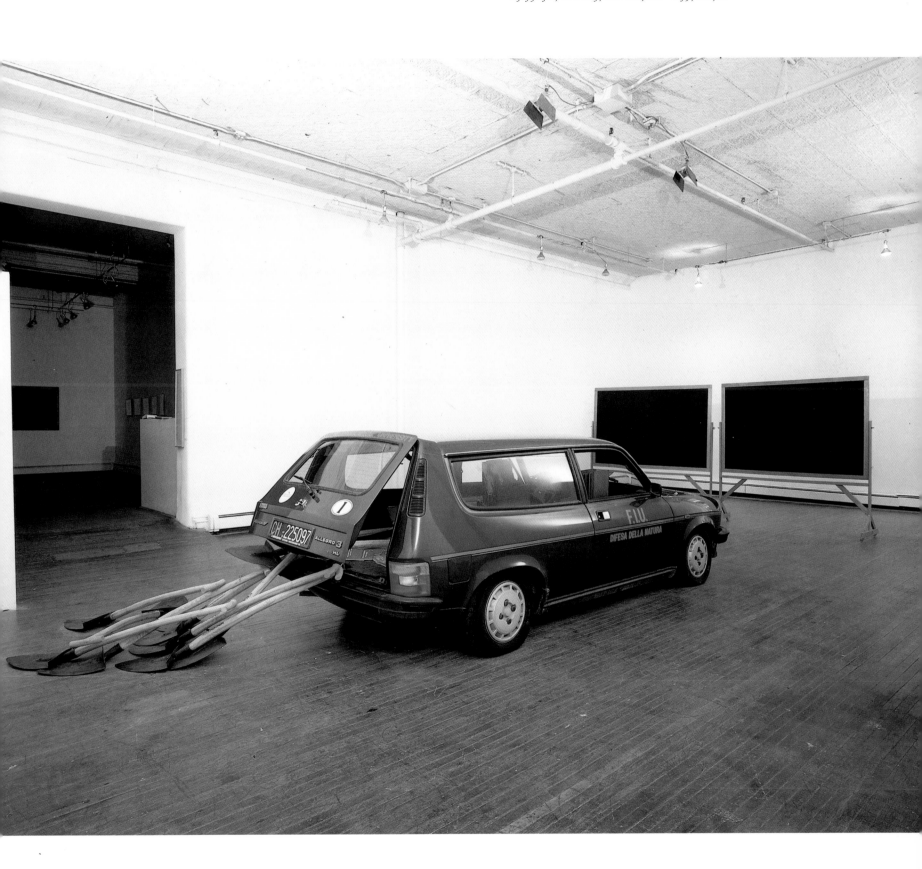

Eduardo Chillida

63 *From Within (Desde dentro).* March 1953
 Forged iron, 38¾ x 11 x 15¾ in. (98.4 x 27.9 x 40 cm.)
 58.1504; SRGM hb. 172

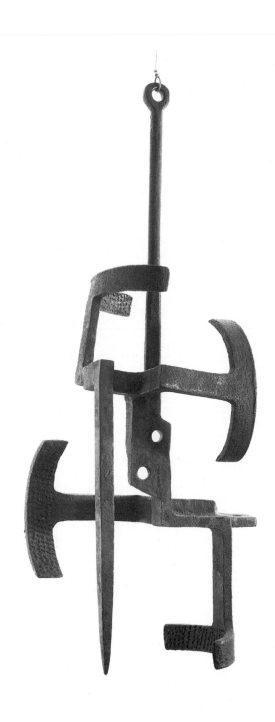

Eduardo Chillida

64 *Three Irons (Iru burni).* 1966
Steel, 3 parts, 17 x 44 x 31½ in. (43.2 x 111.8 x 80 cm.), 21⅝ x 24½ x
5⅞ in. (55 x 62.2 x 14.9 cm.), 22⅝ x 32⅛ x 20¾ in. (57.5 x 81.6 x
52.7 cm.); total 32⅝ x 57½ x 35⅜ in. (57.5 x 146 x 89.8 cm.)
Gift, The Merrill G. and Emita E. Hastings Foundation
85.3257.a–.c

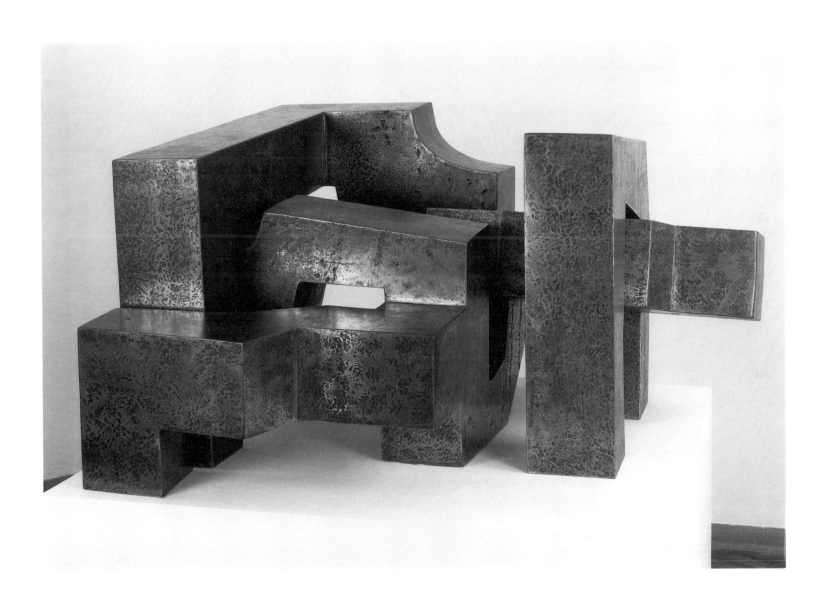

Eduardo Chillida

65 *Mural 103.* 1987
 Fired clay, 119 x 105 x 2½ in. (302.3 x 266.7 x 6.3 cm.)
 Gift, Frank Ribelin
 87.3509

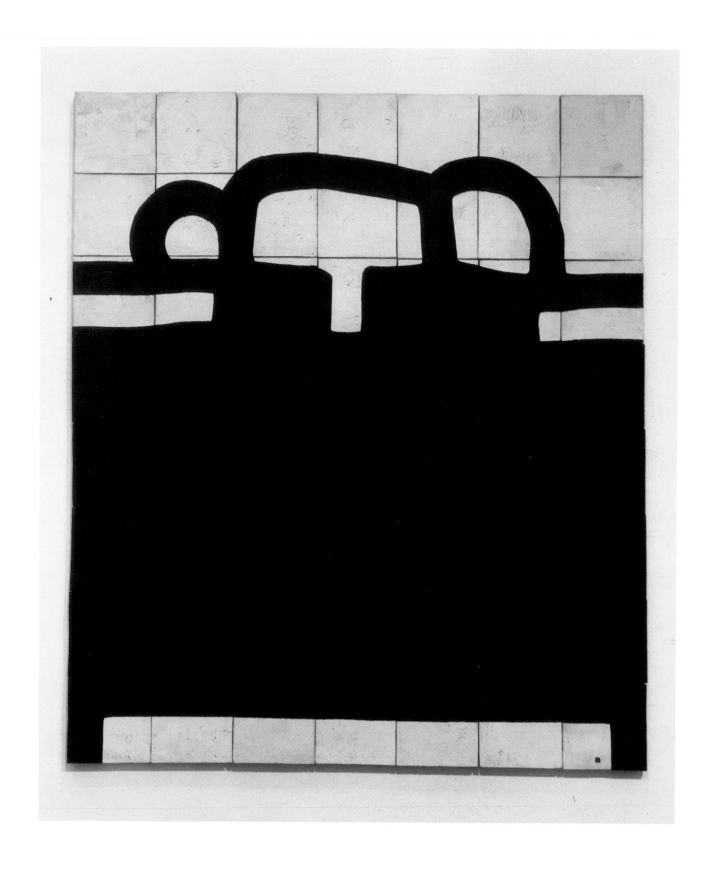

César (César Baldaccini)

66 *Wall Plaque.* 1957
 Welded sheet iron and brass, 68⅞ x 47½ in. (174.9 x 120.6 cm.)
 60.1575

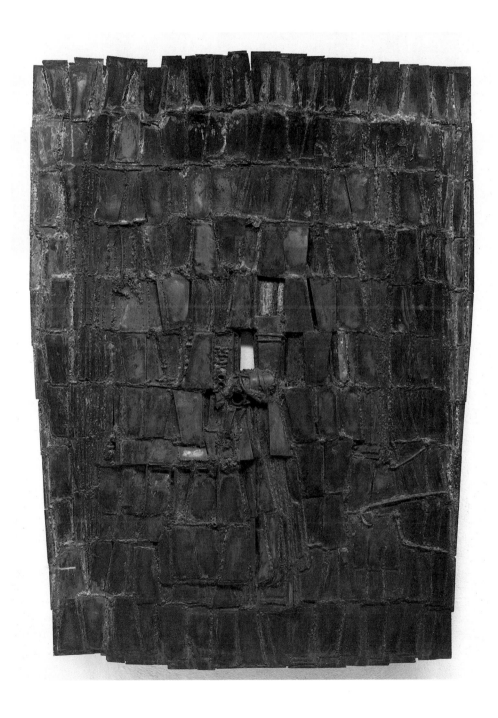

Yves Klein

67 *Blue Sponge (L'Eponge bleue)*. 1959
Dry pigment in synthetic resin on sponge with metal rod and stone base,
39 in. (99 cm.) high
Gift, Mrs. Andrew P. Fuller
64.1752; SRGM hb. 177

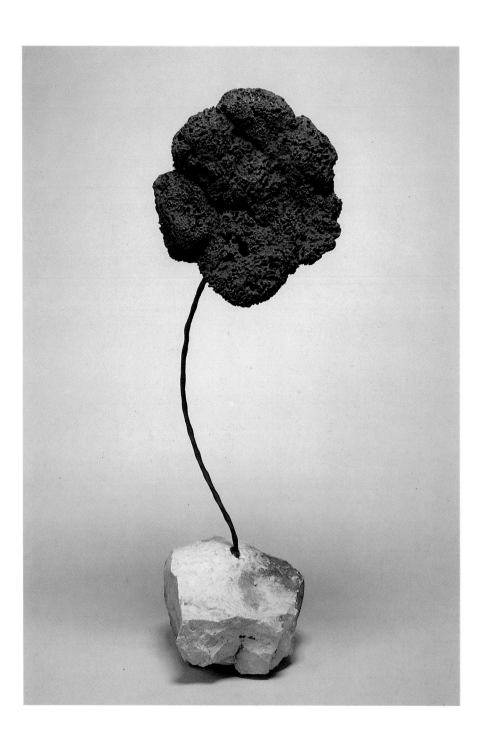

Stanislav Kolibal

68 *Link*. 1969
 Painted cast iron, wire, string and plaster, 24 x 68⅞ x 16¼ in. (61 x
 74.9 x 41.3 cm.)
 80.2755.a, .b

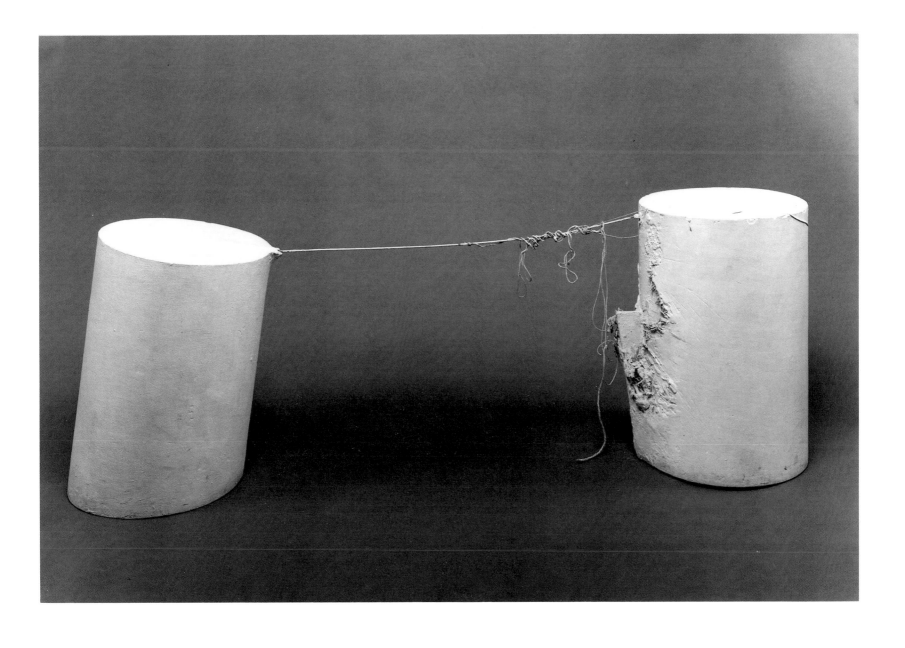

Pol Bury

69 *The Staircase (L'Escalier)*. 1965
 Wood with motor, 78⅝ x 27 x 16¼ in. (200 x 68.6 x 41.3 cm.)
 65.1765; SRGM hb. 182

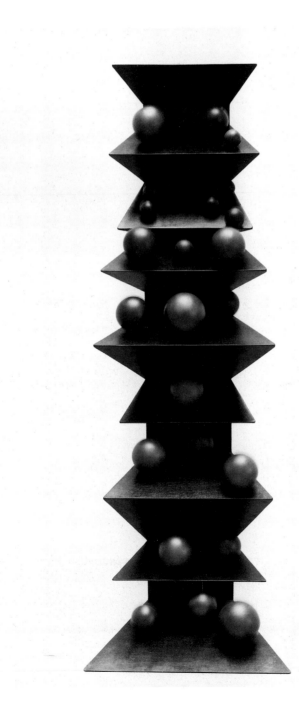

Pol Bury

70 *Fountain.* 1979–80
Stainless steel, 98⅜ x 196⅞ x 94⅜ in. (250 x 530 x 240 cm.)
Gift of the artist
80.2731

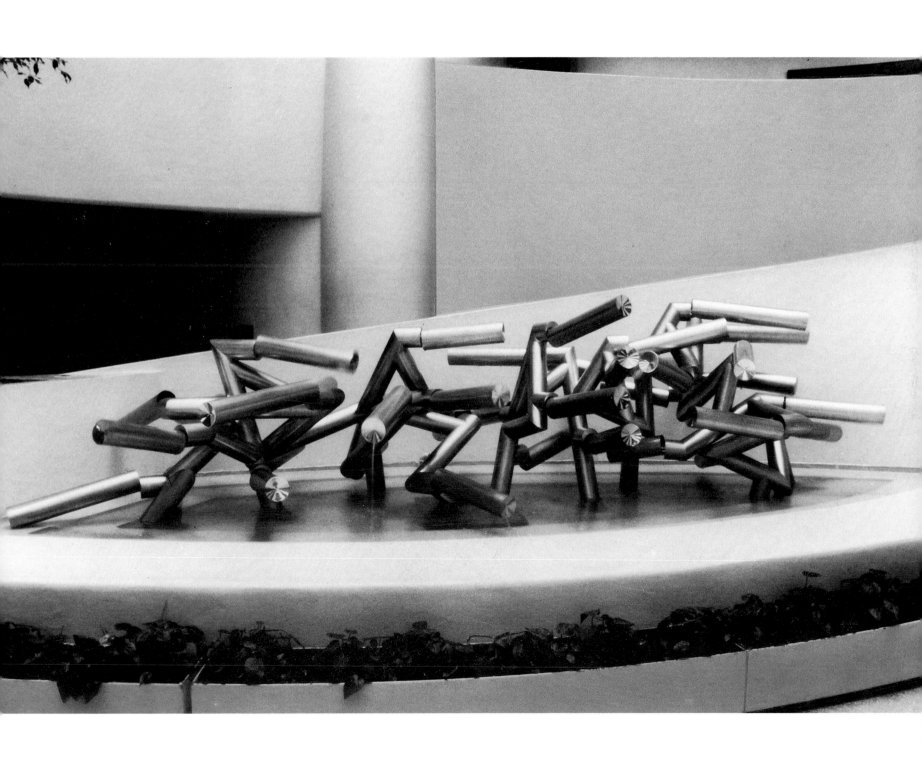

Eduardo Paolozzi

71 *Inversion (Umkehrung)*. 1966
 Chrome-plated steel, 29¼ x 49¾ x 29¾ in. (74.3 x 126.4 x 75.6 cm.)
 Purchase Award, Guggenheim International Exhibition
 67.1866

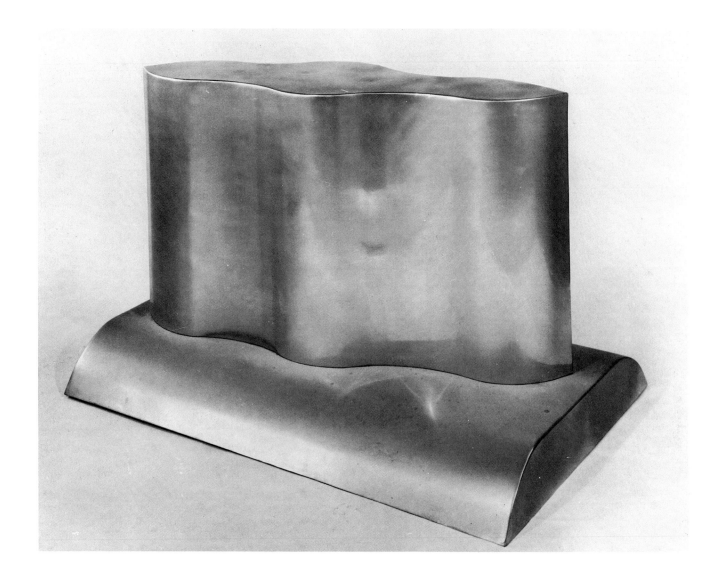

Barry Flanagan

72 *Four Rahsb* 4'67. 1967
 Resin, hessian and sand, 4 units, each 50 x 8⅜ x 8¼ in. (127 x 21.3 x
 20.9 cm.); total 50 x 60 x 60 in. (127 x 152.4 x 152.4 cm.)
 Purchased with funds contributed by The Theodoron Foundation
 69.1905.a–.d

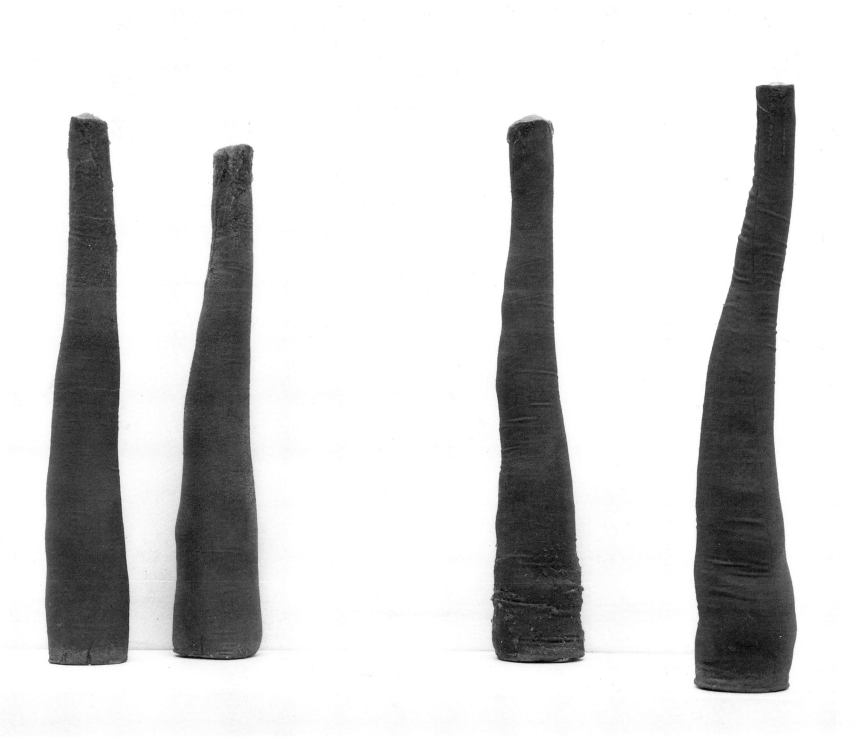

Jean Dubuffet

73 *Bidon l'Esbroufe*. December 11, 1967
 Acrylic on fiberglas-reinforced polyester resin, 65¾ in. (167 cm.) high
 Gift of the artist in honor of Mr. and Mrs. Thomas M. Messer
 70.1920; SRGM hb. 166

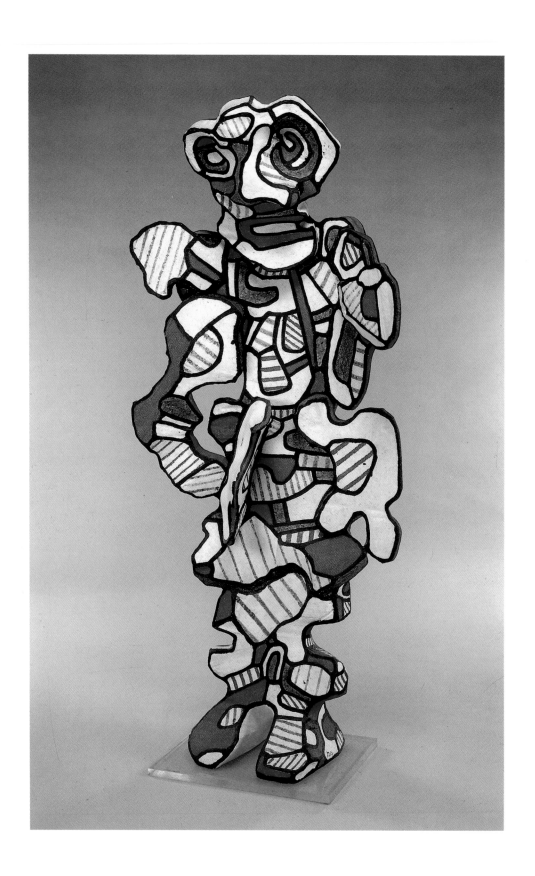

Jean Dubuffet

74 *Mute Permute*. October 1971
Vinyl and acrylic paint on Klegecell, glazed with polyester and fiberglas,
113⅝ x 151½ x 1½ in. (288.6 x 384.8 x 3.8 cm.)
Gift, Mr. and Mrs. Morton L. Janklow
79.2608

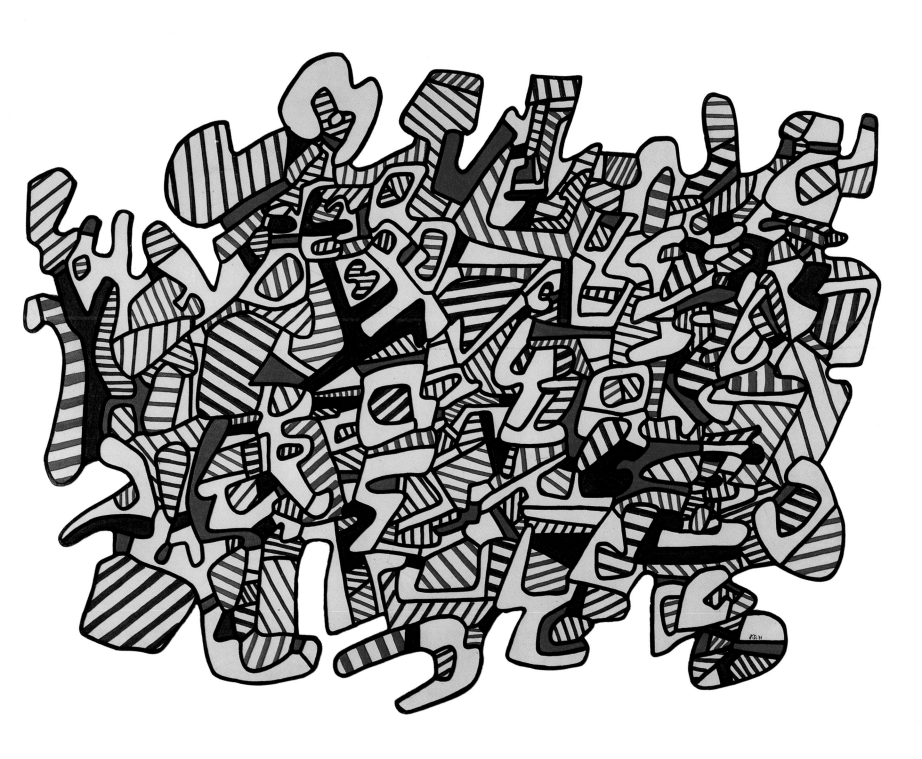

Jean Ipoustéguy

75 *Anatomy (Anatomie)*. 1967
 Carrara marble, 8 x 21⅜ x 25¾ in. (20.3 x 54.3 x 65.4 cm.)
 Gift, Miss Sally Austin
 86.3473

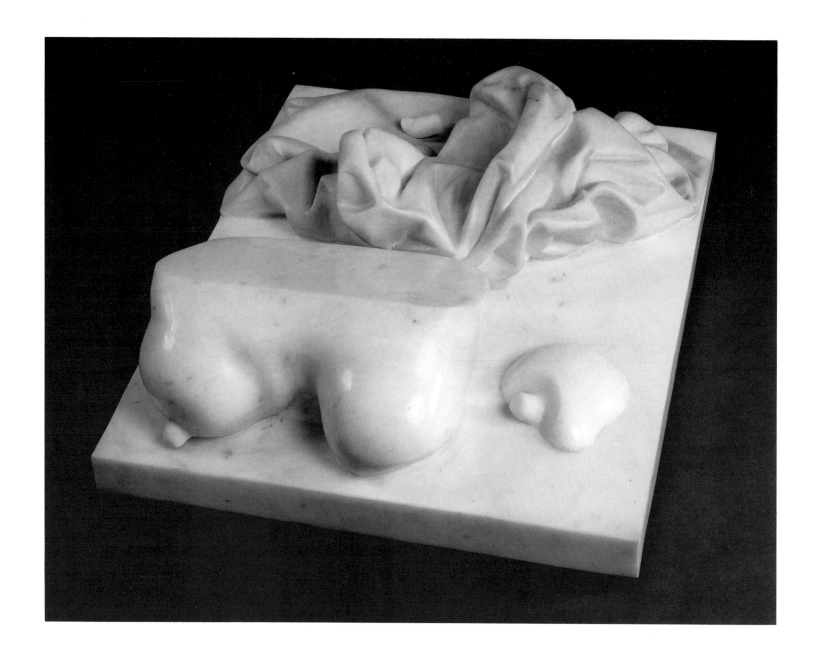

Jean Ipoustéguy

76 *Lenin (Lénine)*. 1967
 Marble and metal, 23 in. (58.4 cm.) high
 68.1872; SRGM hb. 179

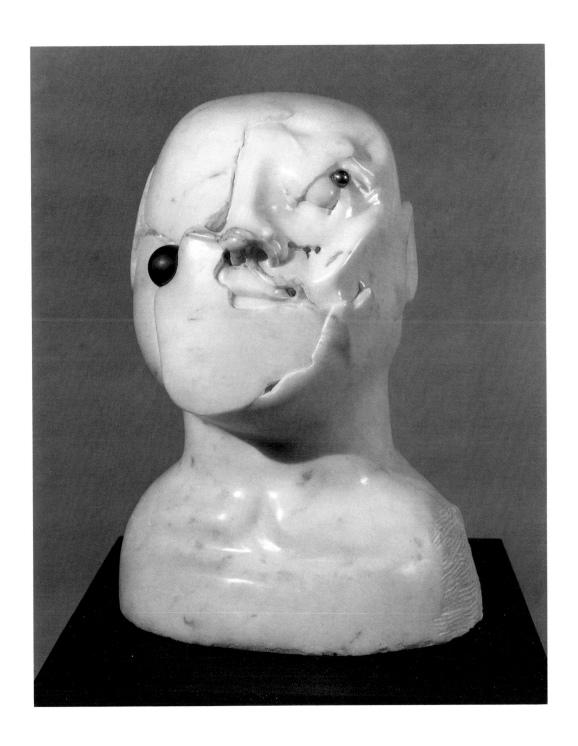

Jean Ipoustéguy

77 *The Great Rule (La Grande Règle).* 1968
Marble, 59½ in. (151.1 cm.) high
68.1873.a, .b

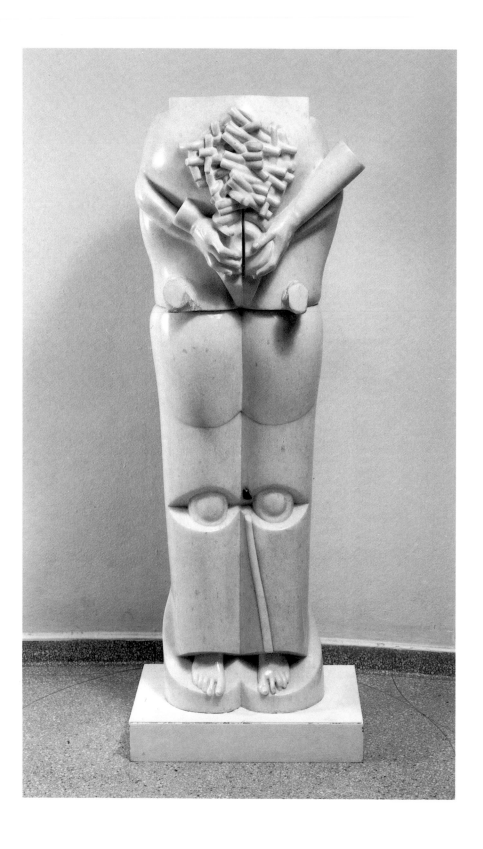

Jiří Kolář

78 *Reverence to Columbus.* 1968–69
Paper collage on plaster and board (chiasmage), 3 parts, total 35½ x
81½ x 48¼ in. (90.2 x 207 x 122.5 cm.)
72.1992.a–.c; SRGM hb. 160

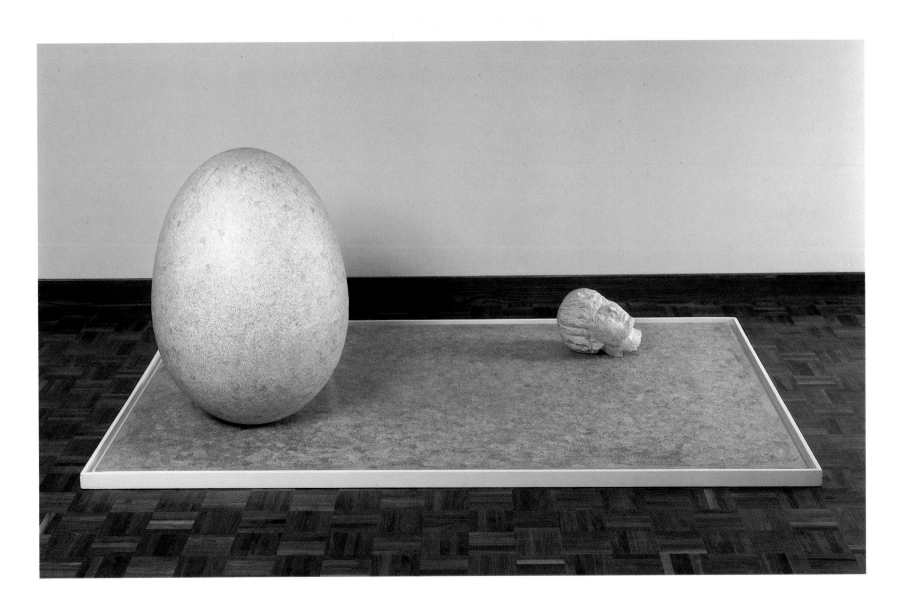

Arman (Armand Fernandez)

79 *Corps de Dame contrebas.* 1974
 Concrete, cello parts, metal, cord and wood, 56½ x 41¼ x 8 in. (143.7 x
 105.1 x 20.3 cm.)
 Purchased with funds contributed by The SCALER Foundation, Eric and
 Sylvie Boissonnas
 83.3027

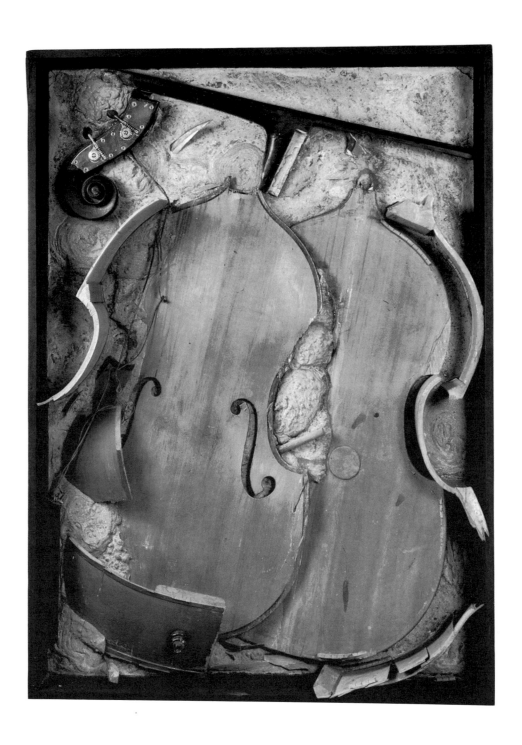

William Tucker

80 *An Ellipse.* 1978
 Steel, 108 x 180 x 50 in. (274.3 x 457.2 x 127 cm.)
 Gift, Mr. and Mrs. Donald Lee Jonas
 79.2559

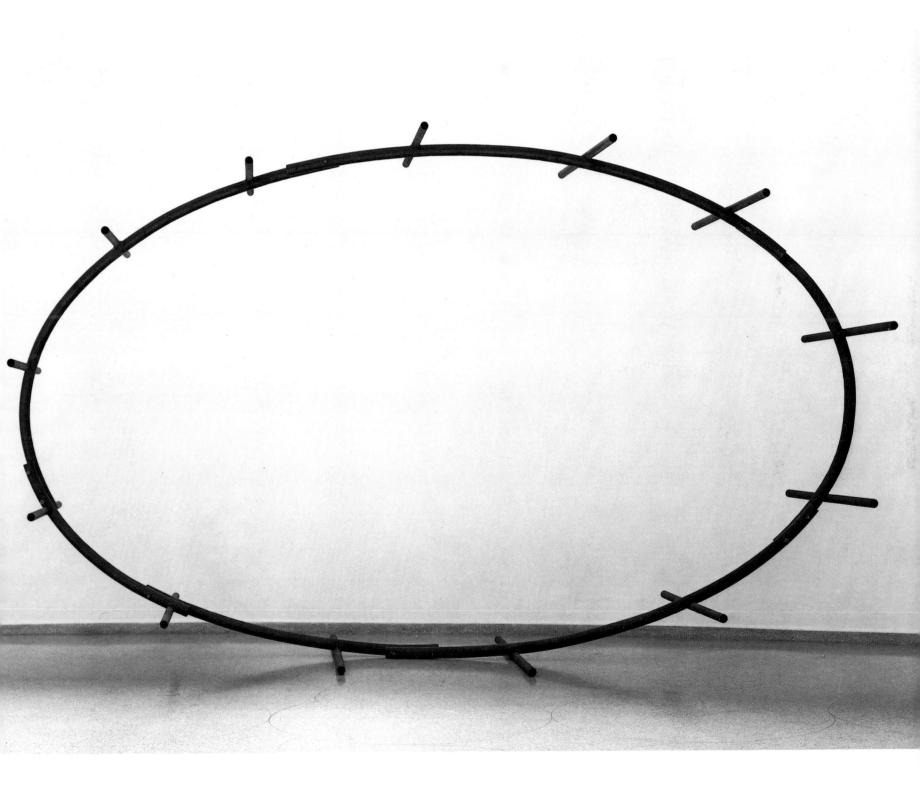

Richard Long

81 *Red Slate Circle.* 1980
 Red slate stones, 336 in. (853.6 cm.) diameter
 Purchased with funds contributed by Stephen and Nan Swid
 82.2895

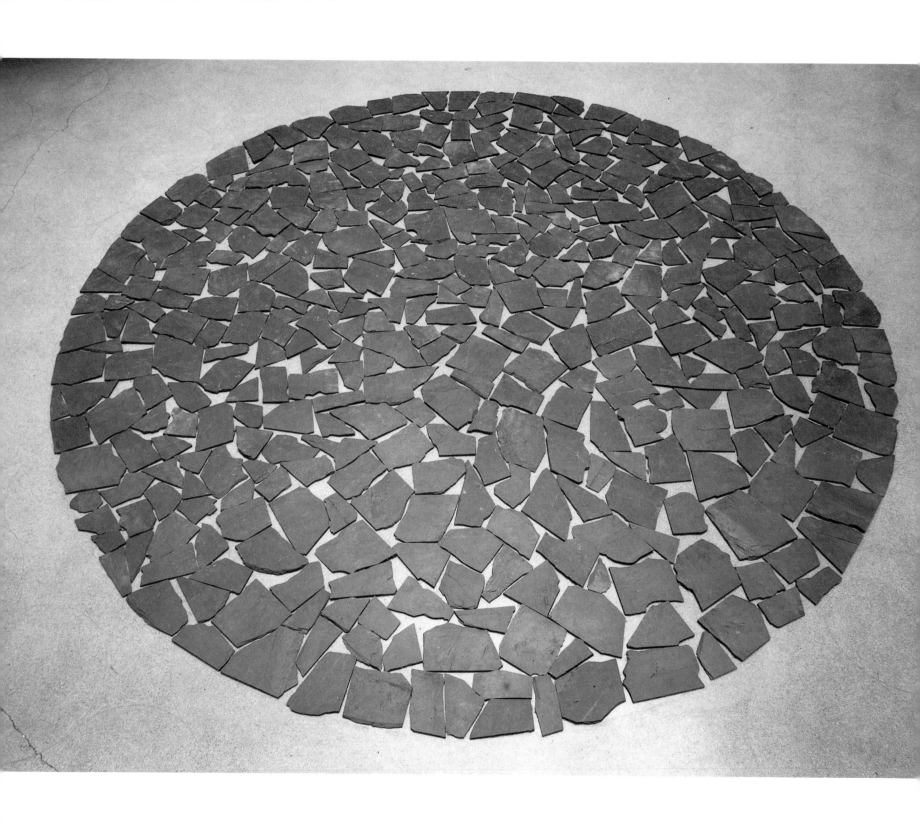

Anthony Caro

82 *Quiver.* 1981
Cast and welded bronze, 71½ x 46 x 23½ in. (181.6 x 116.8 x 59.6 cm.)
Purchased with funds contributed by Mr. and Mrs. Stephen S. Weisglass
82.2909

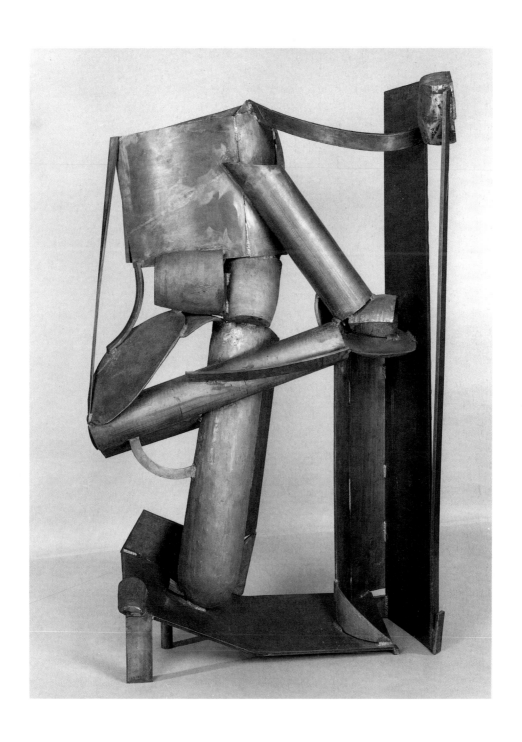

Alexander Calder

83 *Romulus and Remus (Romulus et Remus).* 1928
Wire and wood, 31 x 112 x 30 in. (78.7 x 284.5 x 76.2 cm.)
65.1738.a–.c; SRGM hb. 186

Alexander Calder

84 *Spring (Printemps).* 1928
Wire and wood, 94½ in. (240 cm.) high
Gift of the artist
65.1739; SRGM hb. 187

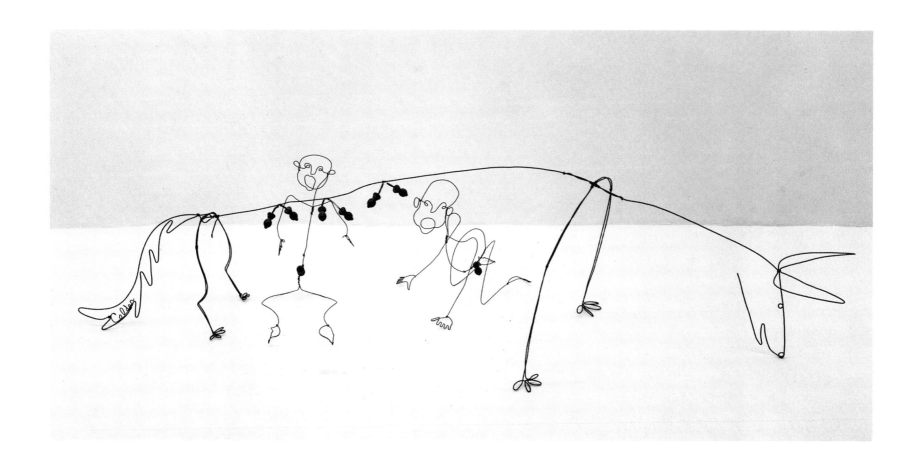

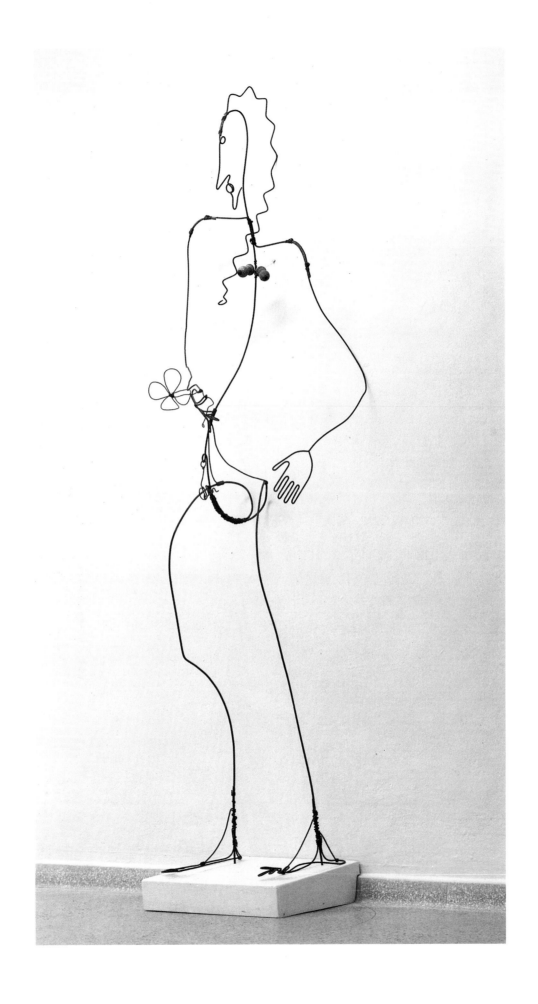

Alexander Calder

85 *Mobile.* ca. 1934
Glass, china, iron wire and thread, 65¾ x 46¹/₁₆ in. (167 x 117 cm.)
Peggy Guggenheim Collection, Venice, The Solomon R. Guggenheim
Foundation
76.2553 PG 139; PGC cat. 24; PGC hb. 98

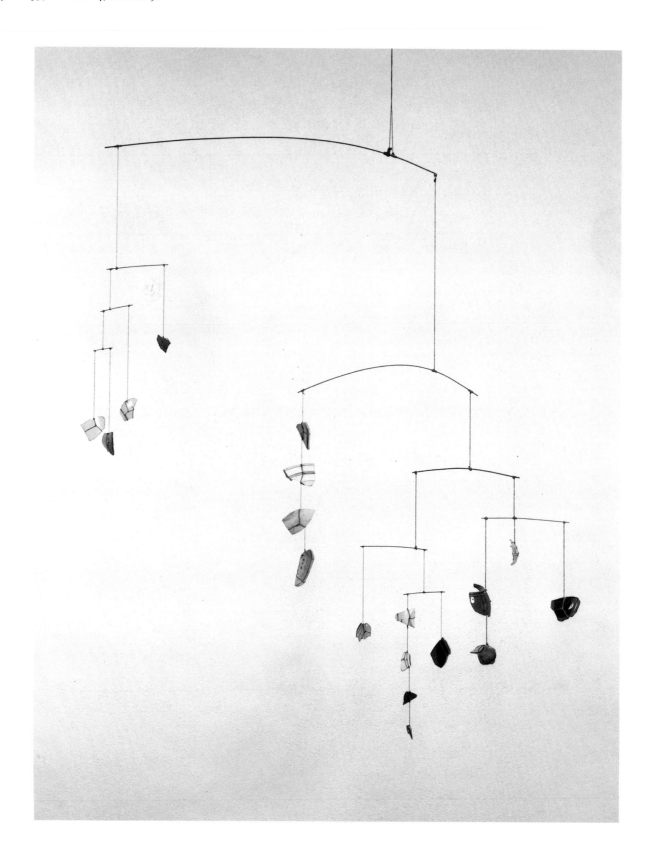

Alexander Calder

86 *Mobile.* 1934(?)
Sheet metal, metal rods and cord, 9 x 16 in. (22.8 x 40.6 cm.)
Collection Mary Reynolds, gift of her brother
54.1388

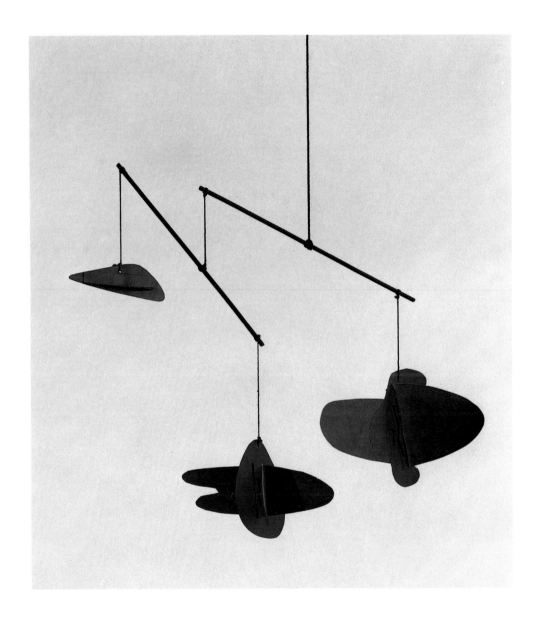

Alexander Calder

87 *Mobile.* 1935(?)
 Glass, metal, wood, pottery and cord, 25 x 23 in. (63.5 x 58.9 cm.)
 Collection Mary Reynolds, gift of her brother
 54.1389

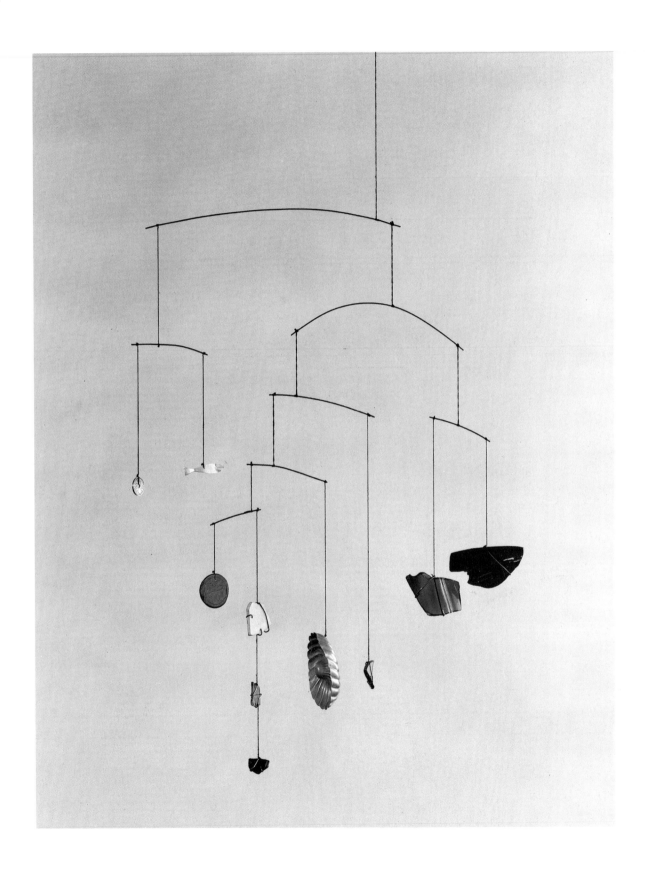

Alexander Calder

88 *Mobile*. 1936(?)
 Wood, metal rods and cord, 39 x 36 in. (99 x 91.5 cm.)
 Collection Mary Reynolds, gift of her brother
 54.1392

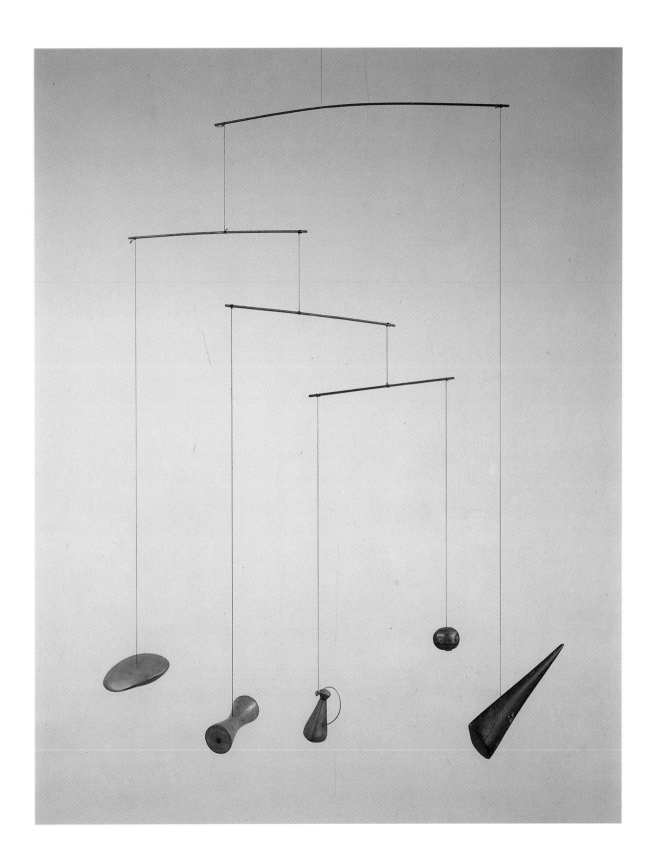

Alexander Calder

89 *Standing Mobile.* 1942
Painted metal, 20½ x 11½ x 10½ in. (52.1 x 29.2 x 26.7 cm.)
Hilla Rebay Collection, Solomon R. Guggenheim Museum, New York
71.1936 R55.a, .b

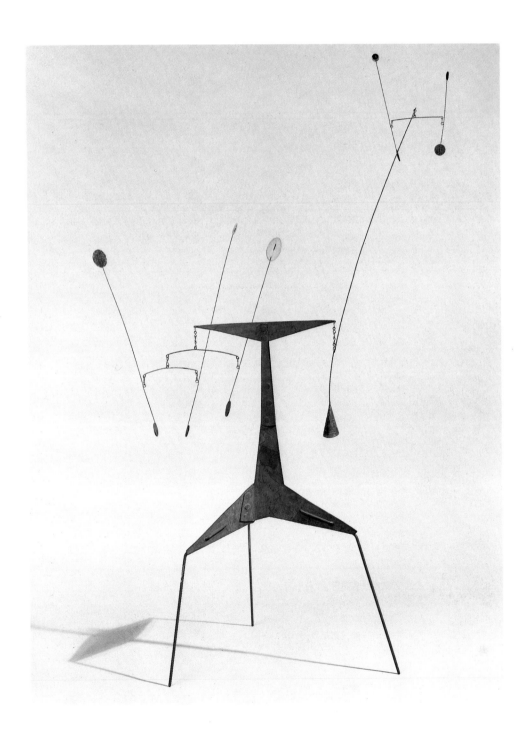

Alexander Calder

90 *Standing Mobile*. Late 1930s or early 1940s
 Painted metal, 51½ x 17½ x 21 in. (130.8 x 44.5 x 53.3 cm.)
 Hilla Rebay Collection, Solomon R. Guggenheim Museum, New York
 71.1936 R54.a–.c

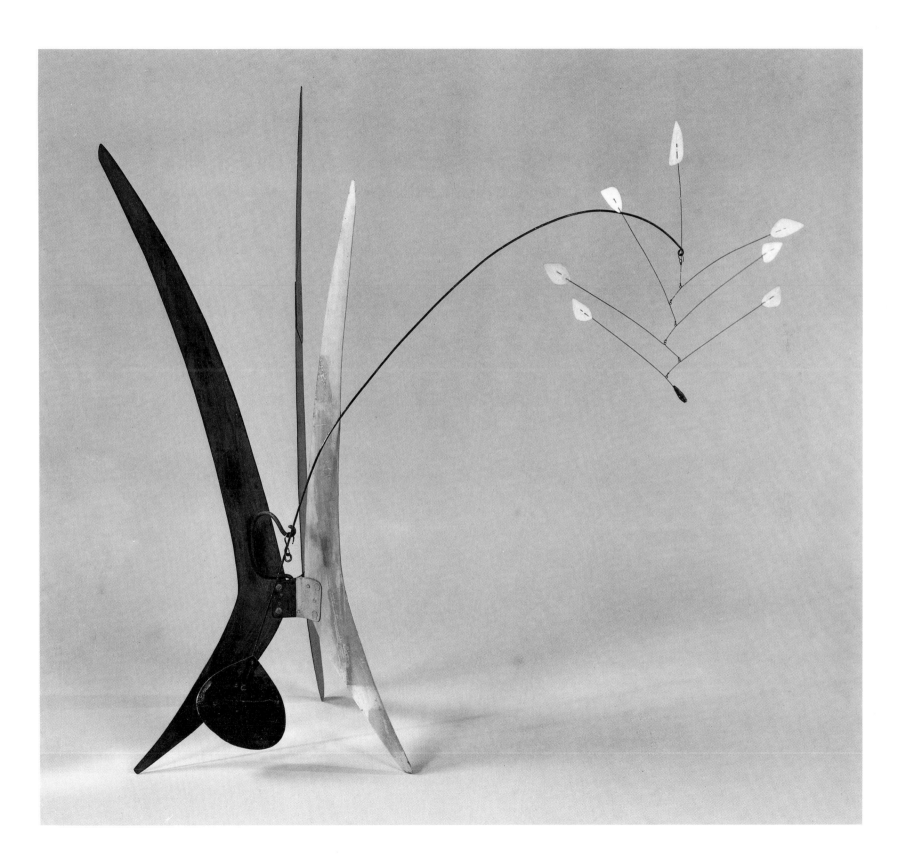

Alexander Calder

91 *Constellation*. 1943
 Wood and metal rods, 22 x 44½ in. (55.9 x 113 cm.)
 Collection Mary Reynolds, gift of her brother
 54.1393; SRGM hb. 188

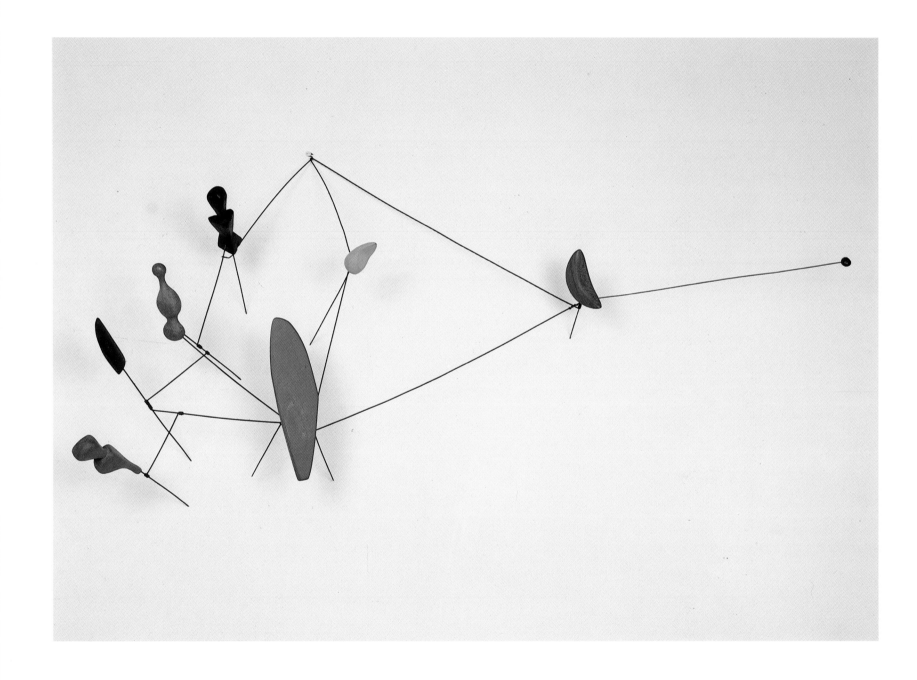

92 *Mobile.* ca. 1943–46
 Wood, metal and cord, 67 x 65 in. (170.2 x 165.1 cm.)
 Collection Mary Reynolds, gift of her brother
 54.1390; SRGM hb. 189

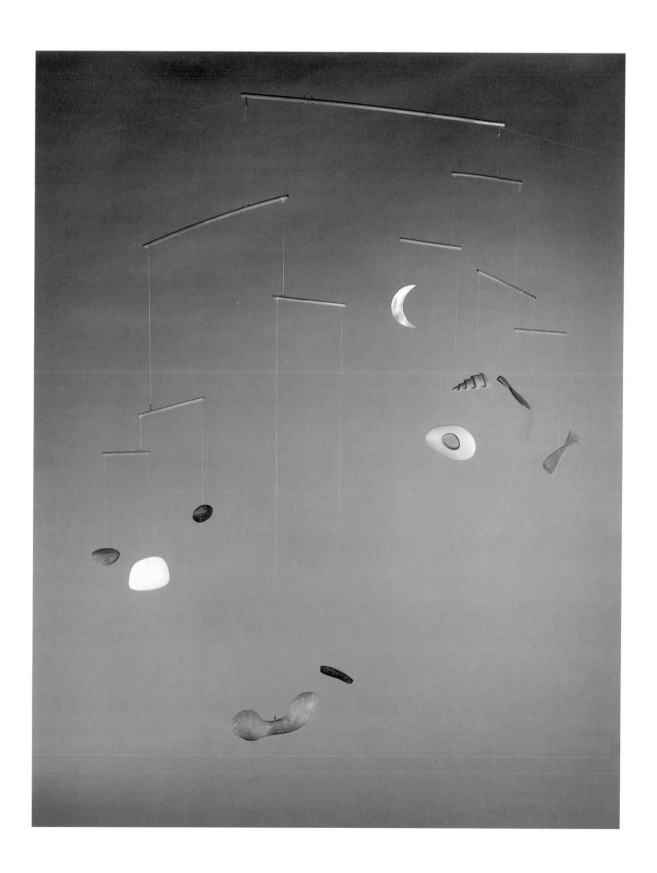

93 *Silver Bedhead*. Winter 1945–46
 Silver, 63 x 51⁹/₁₆ in. (160 x 131 cm.)
 Peggy Guggenheim Collection, Venice, The Solomon R. Guggenheim
 Foundation
 76.2553 PG 138; PGC cat. 26; PGC hb. 100

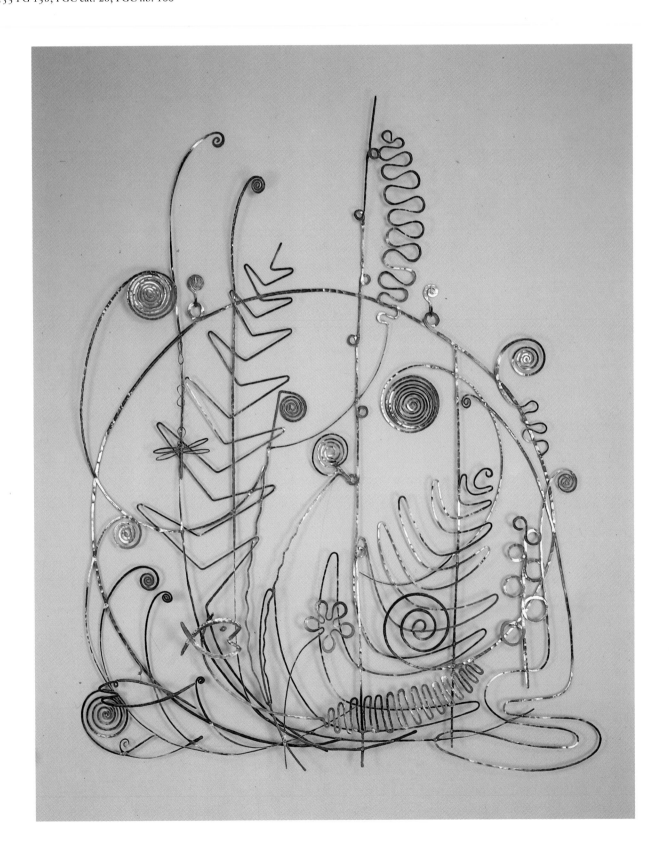

Alexander Calder

94 *Blondie*. 1972
Painted sheet metal and metal rods, 20 x 12 x 14½ in. (50.8 x 30.4 x 36.8 cm.)
Gift, The American Art Foundation
82.2868

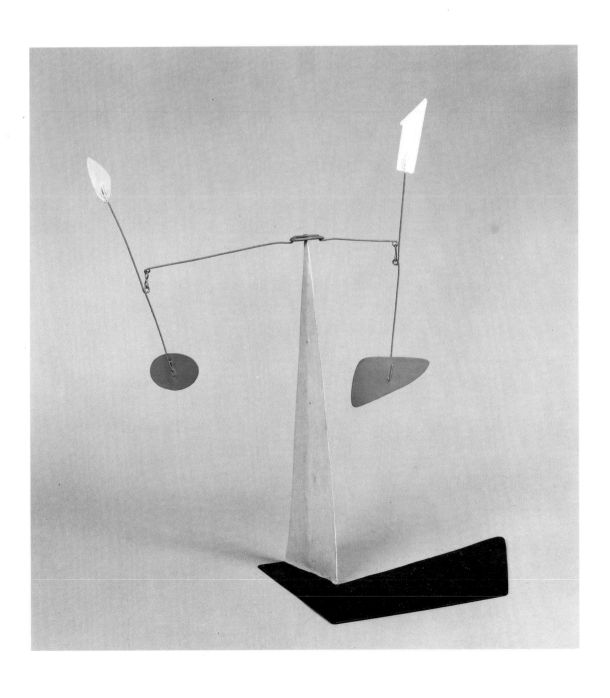

Alexander Calder

95 *Red Lily Pads (Nénuphars rouges).* 1956
 Painted sheet metal, metal rods and wire, 42 x 201 x 109 in. (106.7 x
 510.6 x 276.9 cm.)
 65.1737; SRGM hb. 190

Joseph Cornell

96 *Setting for a Fairy Tale.* 1942
 Box construction, 11⁹⁄₁₆ x 14³⁄₈ x 3⁷⁄₈ in. (29.4 x 36.6 x 9.9 cm.)
 Peggy Guggenheim Collection, Venice, The Solomon R. Guggenheim
 Foundation
 76.2553 PG 125; PGC cat. 37; PGC hb. 104

Joseph Cornell

97 *Untitled (Grand Hôtel de l'Observatoire)*. 1954
Box construction, 18⁵⁄₁₆ x 12¹⁵⁄₁₆ x 3⁷⁄₈ in. (46.5 x 33 x 9.8 cm.)
Partial gift, C. and B. Foundation by exchange
80.2734

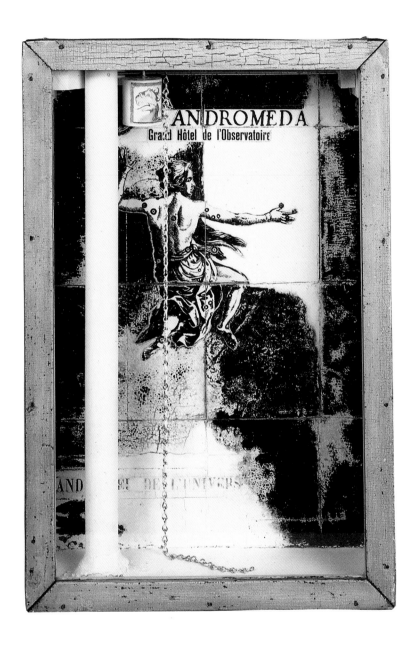

Joseph Cornell

98 *Space Object Box: "Little Bear, etc." motif.* Mid-1950s–early 1960s
 Box construction, 11 x 17½ x 5¼ in. (28 x 44.5 x 13.3 cm.)
 68.1878; SRGM hb. 197

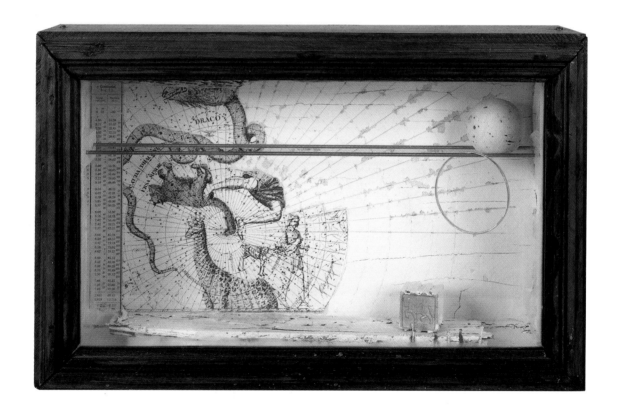

Isamu Noguchi

99 *Enigma.* 1957
Cast iron, 19 in. (48.2 cm.) high
Gift, Eleanor Ward
80.2724

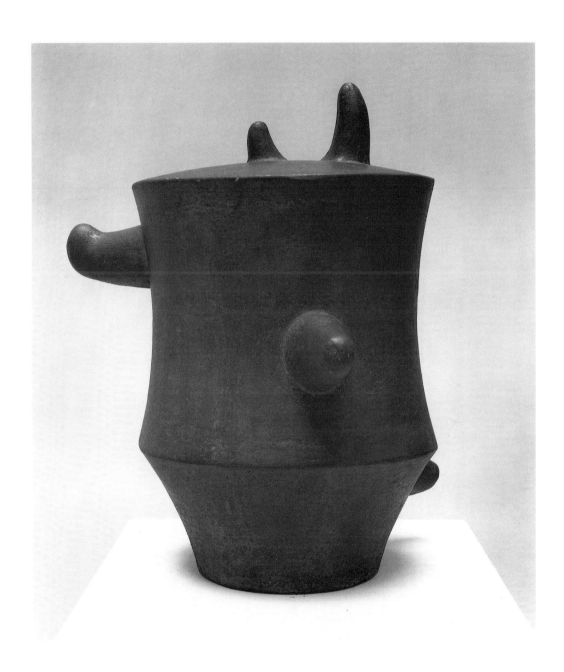

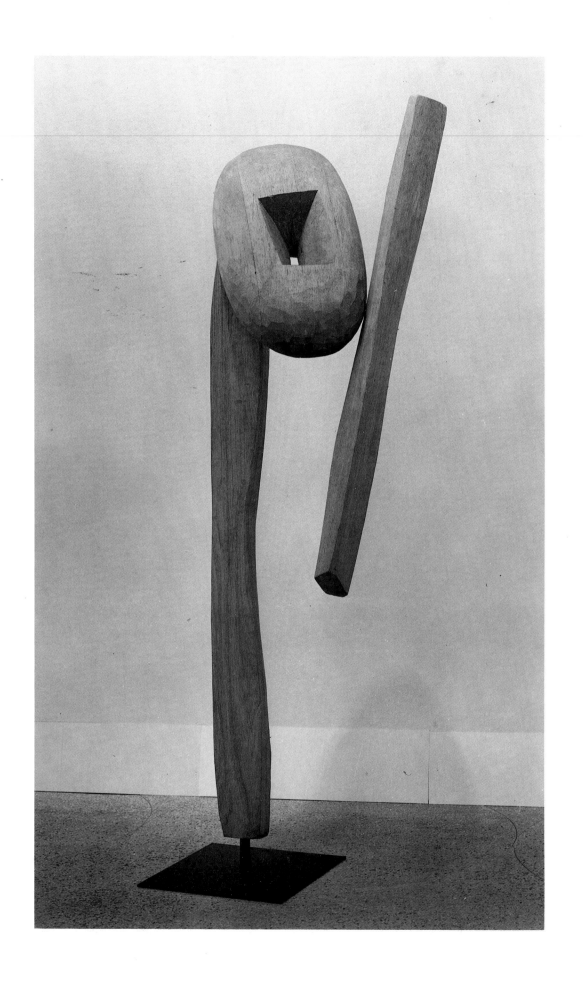

Isamu Noguchi

100 *The Cry.* 1959
 Balsa wood, 87 x 18 x 19 in. (121 x 45.7 x 48.2 cm.), on steel base,
 5 x 18 x 18 in. (12.7 x 45.7 x 45.7 cm.); total 84 x 30 x 19 in. (213.4 x
 76.2 x 45.7 cm.)
 66.1812; SRGM hb. 224

Isamu Noguchi

101 *Lunar.* 1959–60
 Anodized aluminum with wood base, 74½ x 24 x 11⅝ in. (89.2 x 61 x
 29.5 cm.)
 61.1596

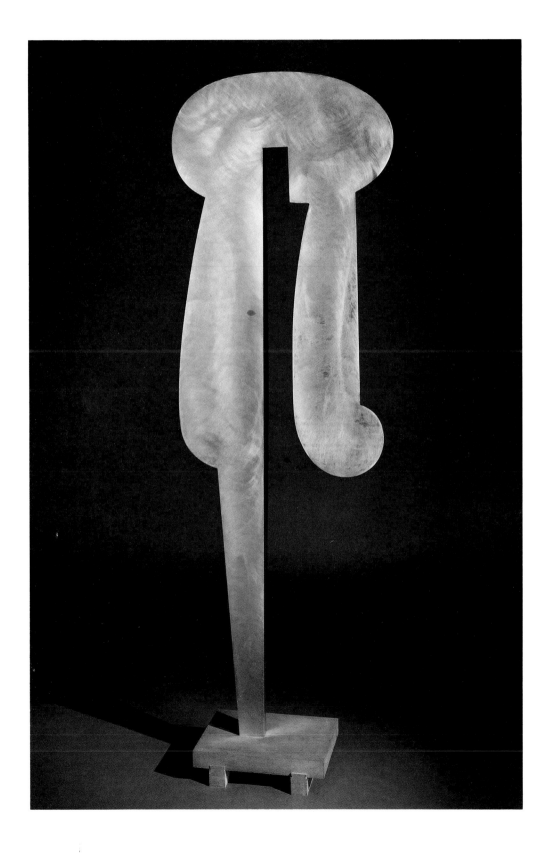

Jim Dine

102 *Bedspring.* 1960
Mixed media assemblage on wire bedspring, 52¼ x 72 x 11 in. (132.7 x
183 x 28 cm.)
Purchased with funds contributed by the Louis and Bessie Adler
Foundation, Inc., Seymour M. Klein, President
85.3258

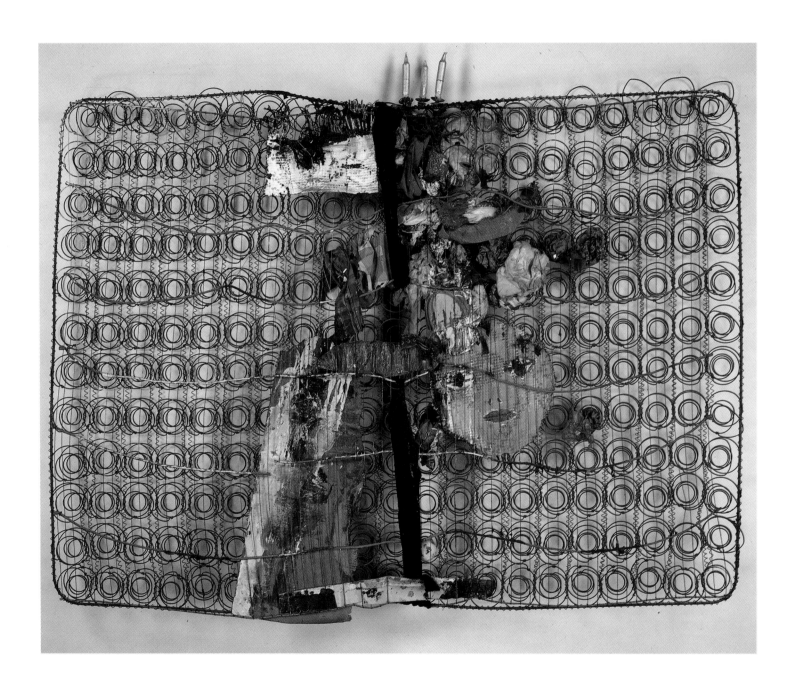

John Chamberlain

103 *Dolores James*. 1962
Welded and painted automobile parts, 76 x 97 x 39 in. (193 x 246.4 x 99.1 cm.)
70.1925; SRGM hb. 232

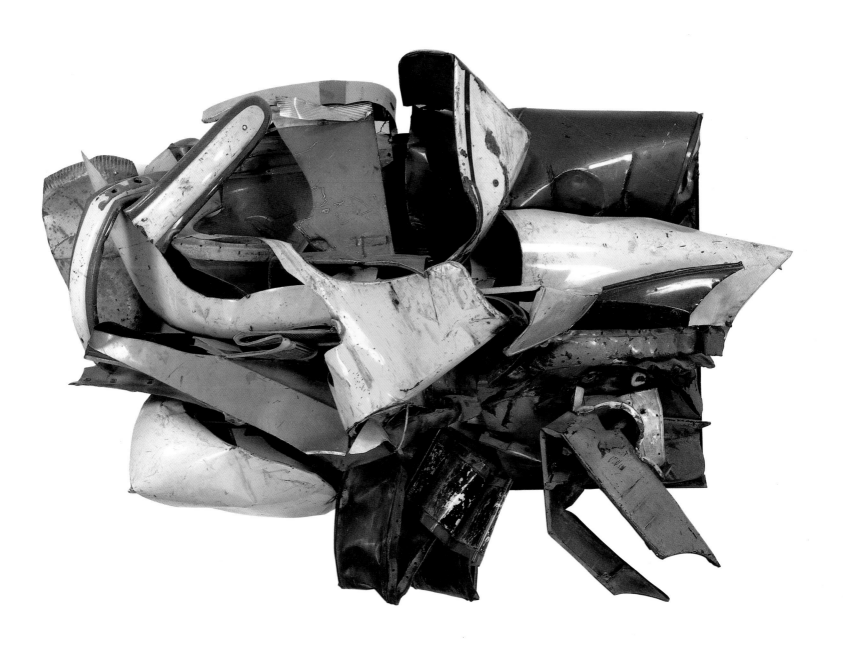

Claes Oldenburg

104 *Soft Pay-Telephone.* 1963
 Vinyl filled with kapok mounted on painted wood panel, 46½ x 19 x 9 in.
 (118.2 x 48.3 x 22.8 cm.)
 Gift, Ruth and Philip Zierler in memory of their dear departed son,
 William S. Zierler
 80.2747

David Smith

105 *Cubi XXVII.* March 1965
 Stainless steel, 111⅜ x 87¾ x 34 in. (282.9 x 222.9 x 86.4 cm.)
 By exchange
 67.1862; SRGM hb. 226

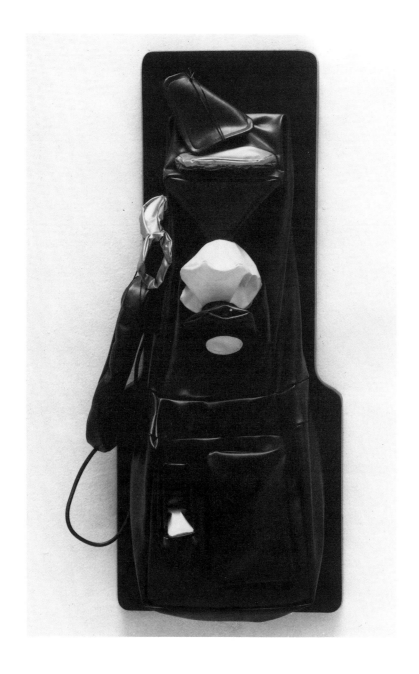

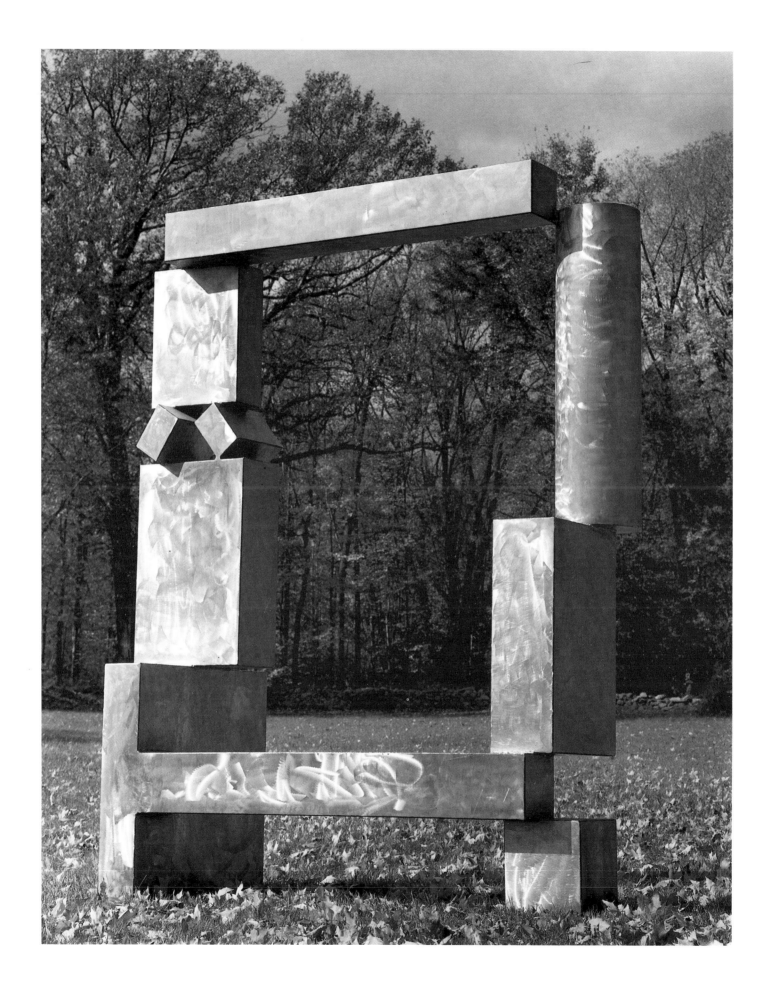

Lucas Samaras

106 *Untitled.* 1965
Box, fake jewels, velvet, silverware and photographs, open 6¼ x 15⅞ x
8½ in. (15.9 x 40.4 x 21.6 cm.)
Gift, Mrs. Andrew P. Fuller
76.2212

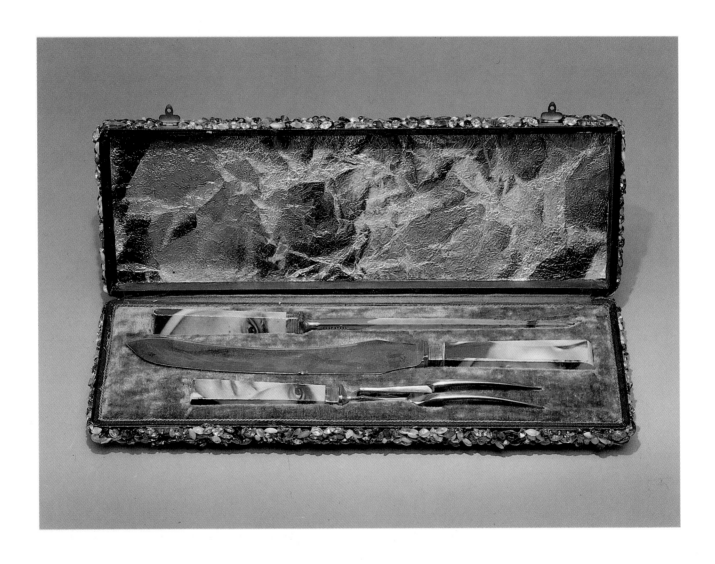

Lucas Samaras

107 *Chicken Wire Box #5*. 1972
Chicken wire and acrylic paint, 11¼ x 8 x 7½ in. (28.5 x 20.3 x 19 cm.)
Gift, Mrs. Andrew P. Fuller
76.2256

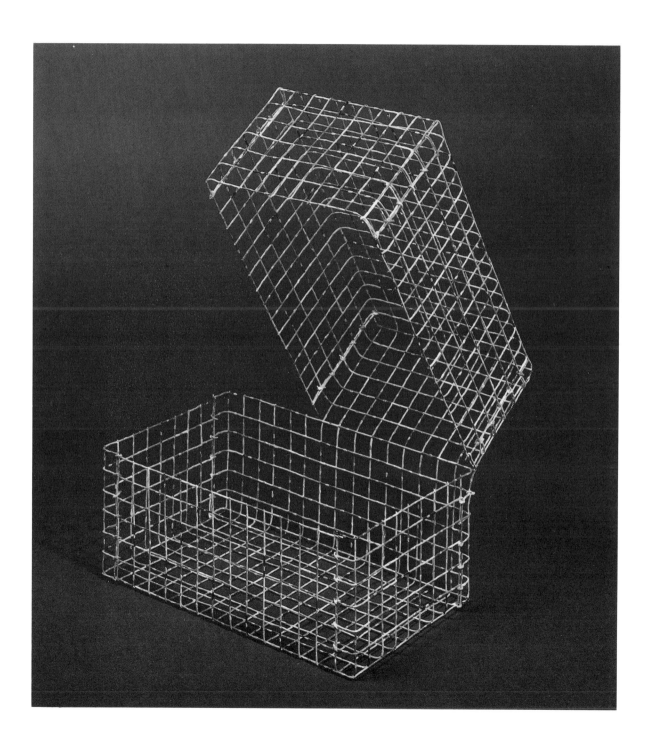

Walter De Maria

108 *Cross.* 1965–66
 Aluminum, 4 x 42 x 22 in. (10.2 x 106.7 x 55.9 cm.)
 73.2033; SRGM hb. 246

109 *Museum Piece.* 1966
 Aluminum, 4 x 36 x 36 in. (10.2 x 91.5 x 91.5 cm.)
 73.2034; SRGM hb. 246

110 *Star.* 1972
 Aluminum, 4 x 44 x 50 in. (10.2 x 111.8 x 127 cm.)
 73.2035; SRGM hb. 246

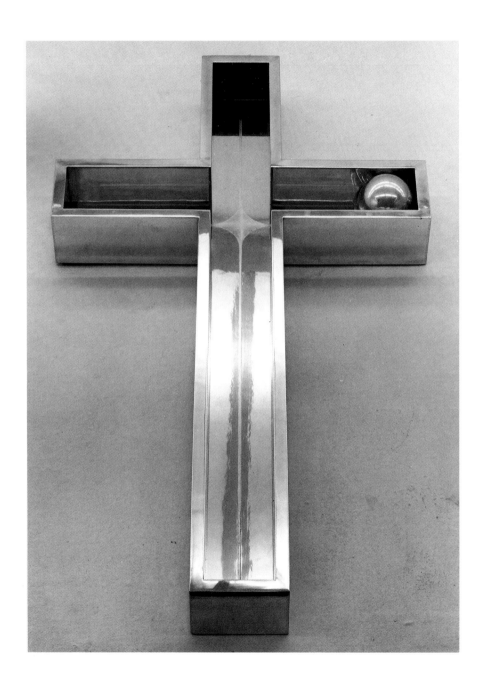

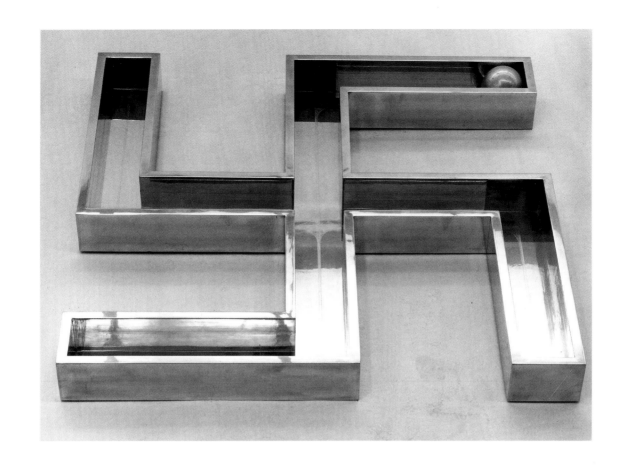

Robert Morris

111 *Untitled.* 1967
 Steel, 9 units, each 36 x 36 x 36 in. (91.4 x 91.4 x 91.4 cm.); total 36 x
 180 x 180 in. (91.4 x 457.3 x 457.3 cm.)
 Purchase Award, Guggenheim International Exhibition
 67.1865.a–.i; SRGM hb. 244

Tony Smith

112　*For W. A.* 1969
Bronze, 2 units, each 60 x 33 x 33 in. (152.3 x 83.8 x 83.8 cm.)
Purchased with the aid of the National Endowment for the Arts in
Washington, D.C., a Federal Agency; matching funds contributed by the
Junior Associates Committee
80.2753.a, .b

Richard Serra

113 *Right Angle Prop.* 1969
 Lead antimony, 72 x 72 x 34 in. (182.8 x 182.8 x 86.4 cm.)
 Purchased with funds contributed by The Theodoron Foundation
 69.1906

Bruce Nauman

114 *Dead Center*. 1969
Steel, 3 x 15 x 15 in. (7.6 x 38.1 x 38.1 cm.)
Purchased with funds contributed by The Theodoron Foundation
69.1900

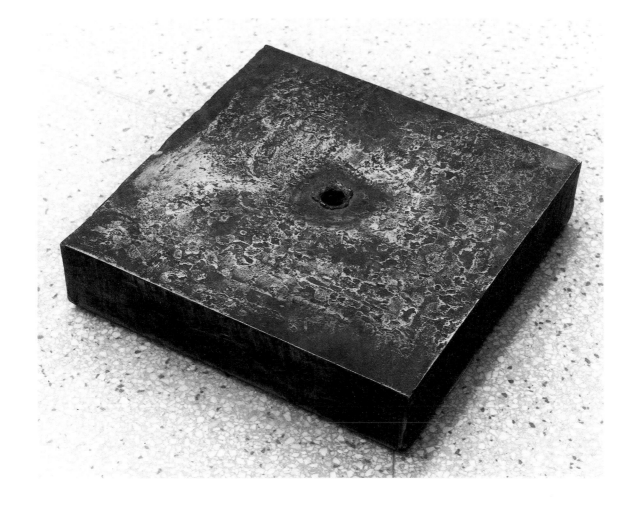

Larry Bell

115 *Untitled.* 1969
 Glass and stainless steel, 20 x 20 x 20 in. (50.8 x 50.8 x 50.8 cm.), on
 plexiglass base, 40⅝ x 20¼ x 20¼ in. (103.1 x 51.4 x 51.4 cm.); total
 60⅝ x 24½ x 24½ in. (154 x 62.2 x 62.2 cm.)
 Gift, The American Art Foundation
 77.2318; SRGM hb. 249

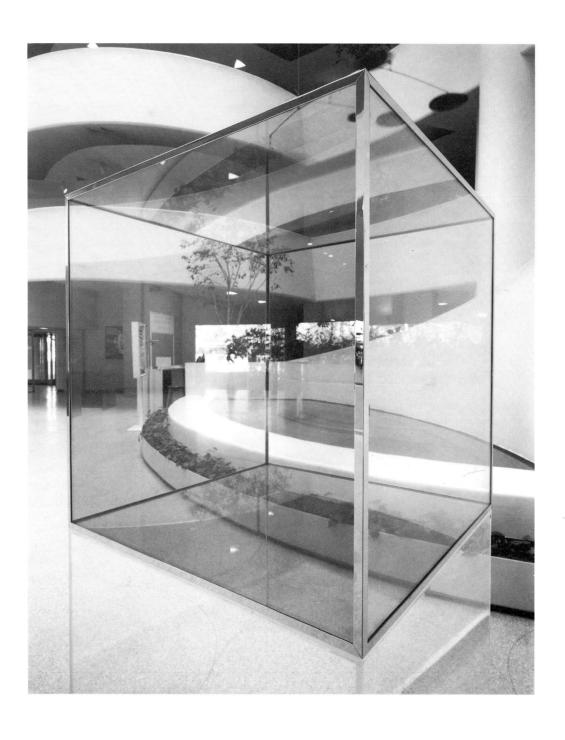

Eva Hesse

116 *Expanded Expansion.* 1969
Fiberglas and rubberized cheesecloth, 3 units of 3, 5 and 8 poles each,
122 x 60 in. (310 x 152.4 cm.), 122 x 120 in. (310 x 304.8 cm.), 122 x
180 in. (310 x 457.2 cm.)
Gift, Family of Eva Hesse
75.2138.a–.c; SRGM hb. 247

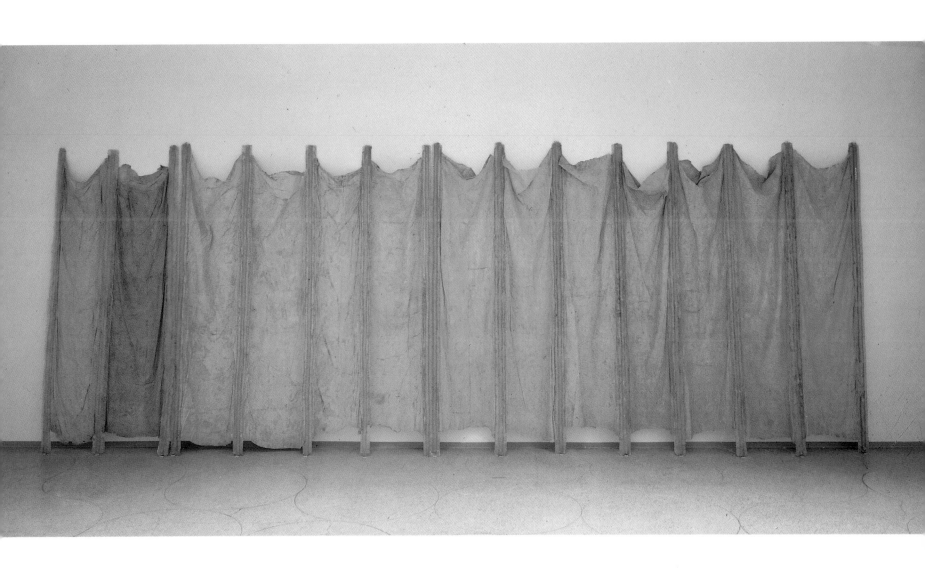

Louise Nevelson

117 *Luminous Zag: Night.* 1971
Painted wood, 105 boxes, each 16⅝ x 12⅝ x 10¾ in. (42.2 x 32 x 27.3
cm.); total 120 x 193 x 10¾ in. (304.8 x 490.3 x 27.3 cm.)
Gift, Mr. and Mrs. Sidney Singer
77.2325.a–.bbbb; SRGM hb. 225

Louise Nevelson

118 *White Vertical Water.* 1972
Painted wood, 26 parts, total 216 x 108 in. (549 x 277.5 cm.)
Gift, Mr. and Mrs. James J. Shapiro
85.3266.a–.z

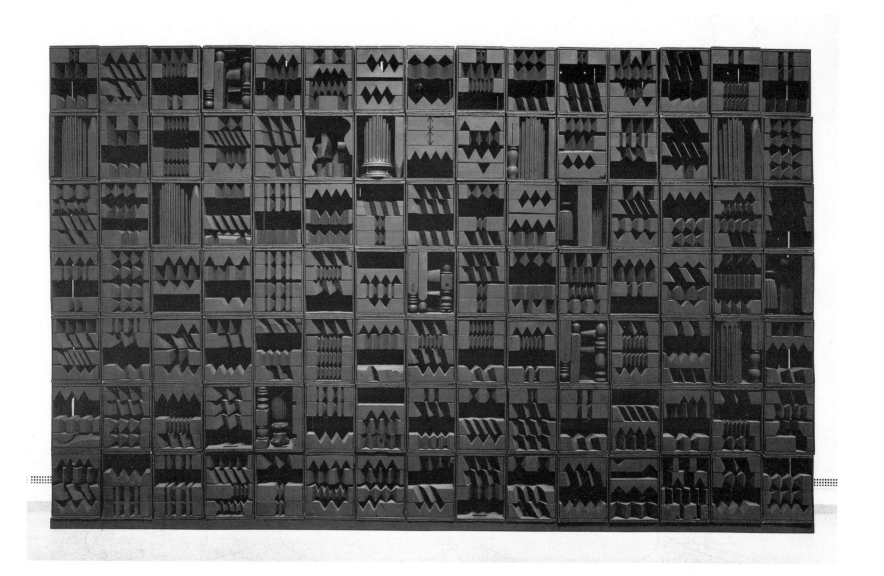

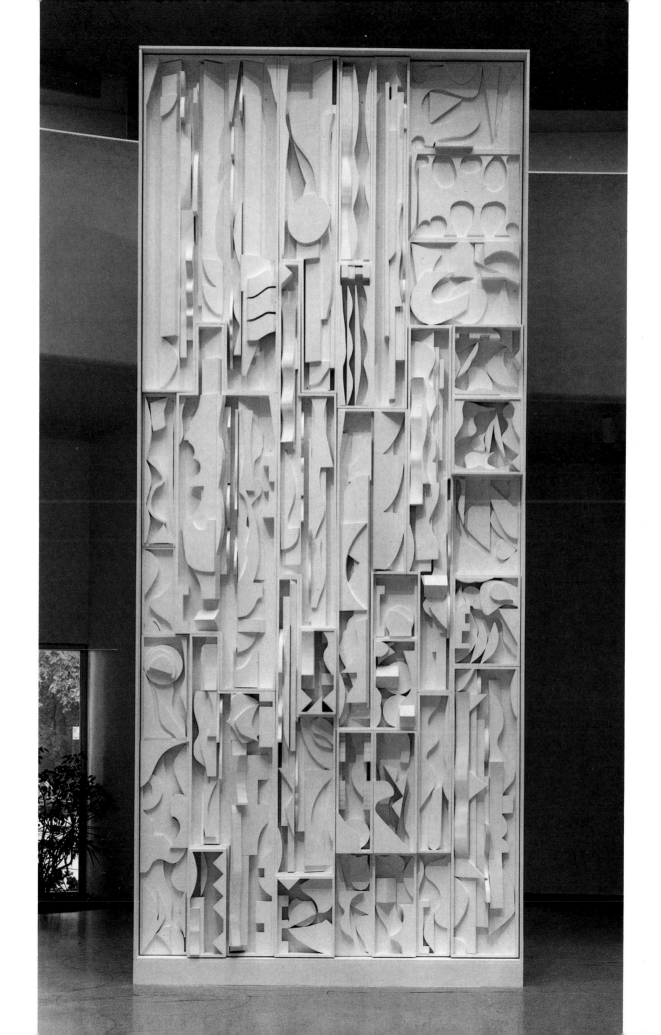

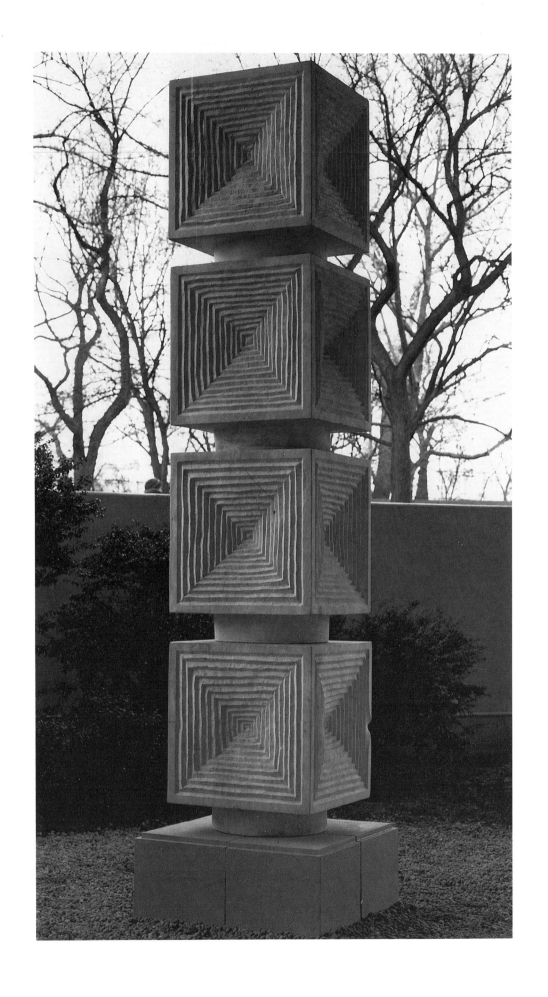

Minoru Niizuma

119 *Castle of the Eye.* 1972
Lee, Massachusetts, marble, 4 parts, each 25 x 24 x 24 in. (63.5 x 61 x 61 cm.); total 100 x 24 x 24 in. (254 x 61 x 61 cm.)
Purchased with the aid of the National Endowment for the Arts in Washington, D.C., a Federal Agency; matching funds contributed by an anonymous donor
76.2290.a–.d

George Segal

120 *Picasso's Chair.* 1973
Plaster, wood, cloth, rubber and string, 78 x 60 x 32 in. (198.1 x 152.4 x 81.3 cm.)
Gift, Dr. Milton D. Ratner
76.2279.a, .b; SRGM hb. 234

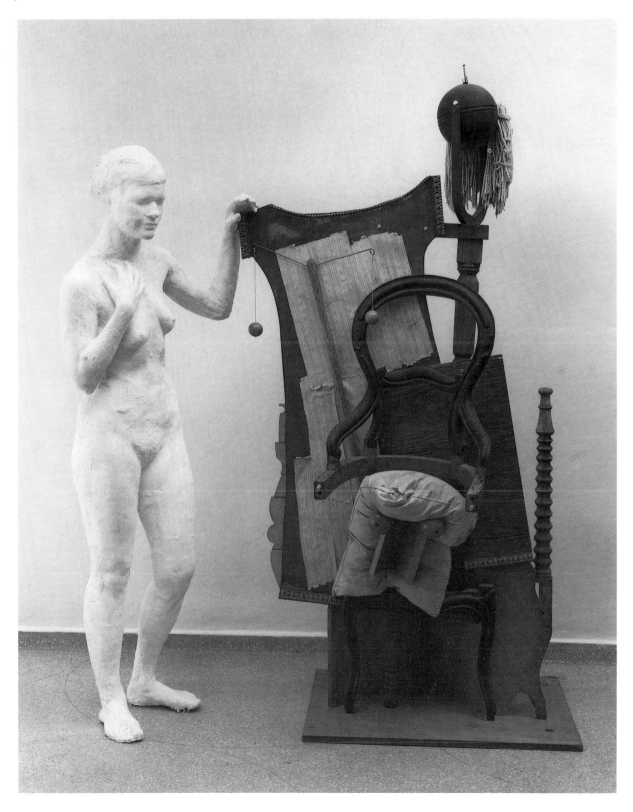

Linda Benglis

121 *Two.* 1973
Sparkle, enamel and silver paint on plaster, cotton bunting and aluminum
screen, 31 x 12½ x 16½ in. (78.8 x 31.7 x 41.9 cm.)
Gift, Mrs. Andrew P. Fuller
76.2259

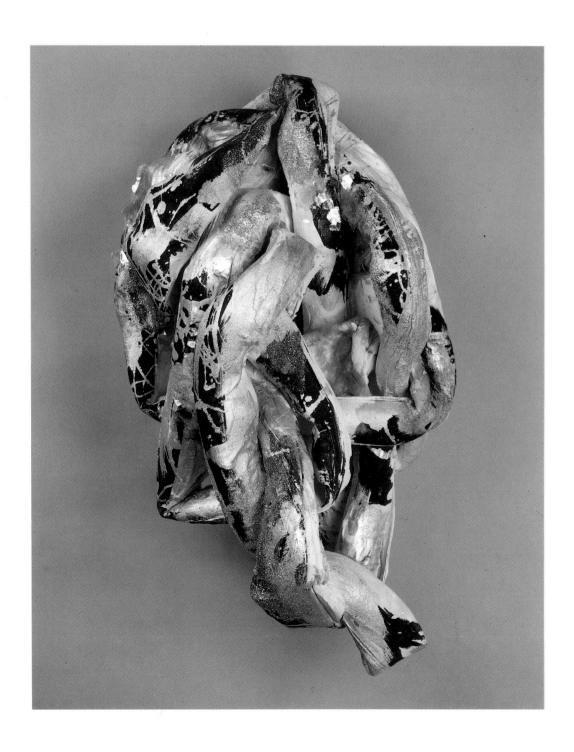

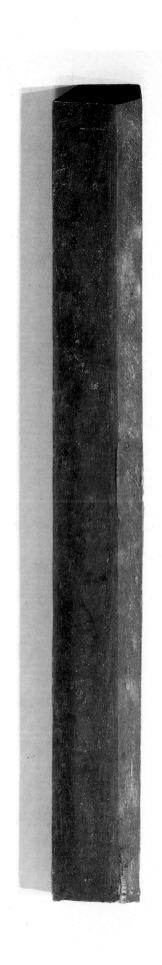

John Duff

122 *Extended Polygon No. 3*. 1974

Fiberglas and brick exterior paint, 65⅛ x 7¼ x 4⅞ in. (165.4 x 18.4 x 12.4 cm.)

Theodoron Purchase Award, through funds contributed by Mr. and Mrs. Irving Rossi, Mr. and Mrs. Sidney Singer, The Theodoron Foundation and The Walter Foundation

77.2308

Richard Stankiewicz

123 *Untitled.* 1975
 Mild steel, 70 x 36 x 37 in. (177.8 x 91.4 x 94 cm.)
 Purchased with the aid of the National Endowment for the Arts in
 Washington, D.C., a Federal Agency; matching funds contributed by
 anonymous donors
 76.2268; SRGM hb. 233

George Rickey

124 *Two Open Rectangles Excentric VI, Square Section.* 1976–77
 Stainless steel, 144 x 36 in. (366 x 91.4 cm.)
 Purchased with the aid of the National Endowment for the Arts in
 Washington, D.C., a Federal Agency; matching funds contributed by
 Evelyn Sharp and anonymous donors
 78.2518.a–.d; SRGM hb. 227

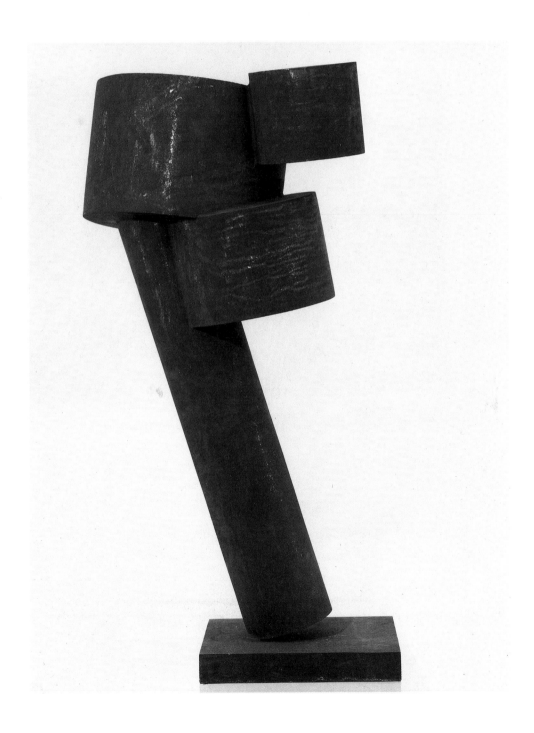

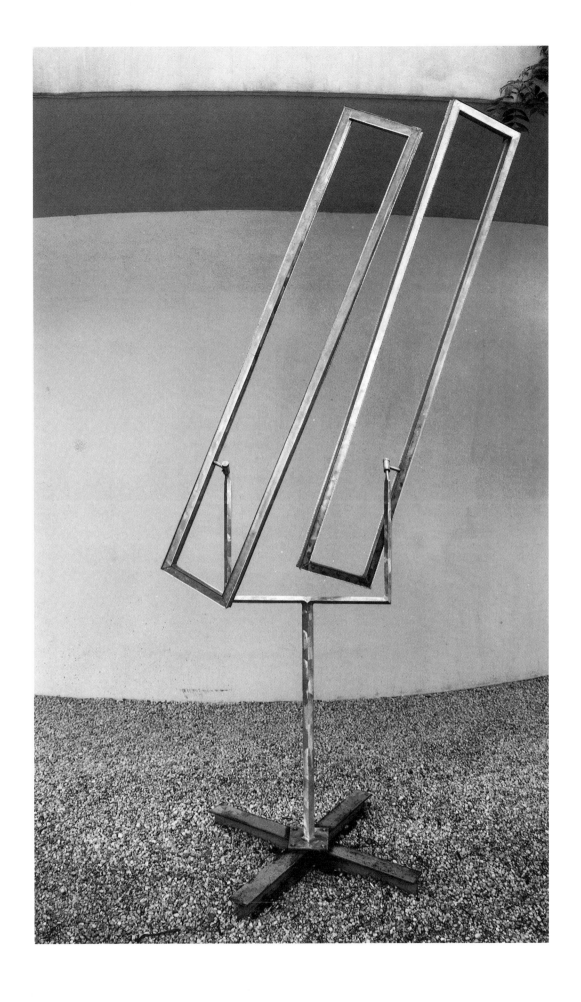

Carl Andre

125 *Trabum.* 1977
 Douglas fir, 9 units, each 12 x 12 x 36 in. (30.5 x 30.5 x 91.4 cm.); total
 36 x 36 x 36 in. (91.4 x 91.4 x 91.4 cm.)
 Purchased with the aid of the National Endowment for the Arts in
 Washington, D.C., a Federal Agency; matching funds contributed by Mr.
 and Mrs. Donald Jonas
 78.2519.a–.i; SRGM hb. 245

Vitaly Komar and Alexander Melamid

126 *Crete ca. 30,000–10,000 B.C. (The Golden Age).* 1978
 Minotaurus, bone, horn, teeth and wire, 70 in. (177.8 cm.) high;
 Homo Tetrahedron, bone and wire, 14½ x 18 x 17 in. (36.8 x 45.7 x 43.2
 cm.); *Homo Cube*, bone and wire, 18 x 21 x 21 in. (45.7 x 53.3 x
 53.3 cm.); *Homo Octohedron*, bone and wire, 24 x 17 x 24 in. (61 x 43.2
 x 61 cm.); *Drawing of Hypothetical Reconstruction*, chalk on paper, 39¼
 x 29⁹⁄₁₆ in. (99.7 x 75.1 cm.); *Drawing of Hypothetical Reconstruction*,
 chalk on paper, 39¼ x 29⁹⁄₁₆ in. (99.7 x 75.1 cm.); *Tablet with
 Inscription in Linear Alphabet B "I Have Been in Arcadia,"* marble, 32 x
 23 x 3 in. (81.3 x 58.4 x 7.6 cm.); *International Herald Tribune Article*,
 newspaper and collage, 23½ x 17¼ in. (59.7 x 43.8 cm.)
 Gift, Professor and Mrs. Alexander Melamid
 82.2964.a–.h

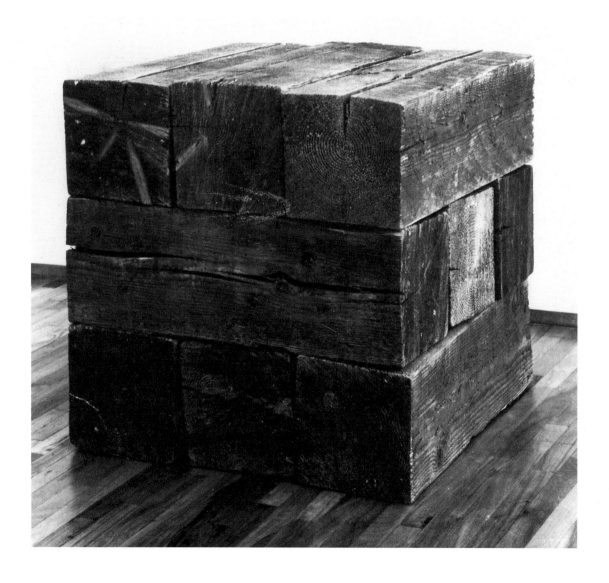

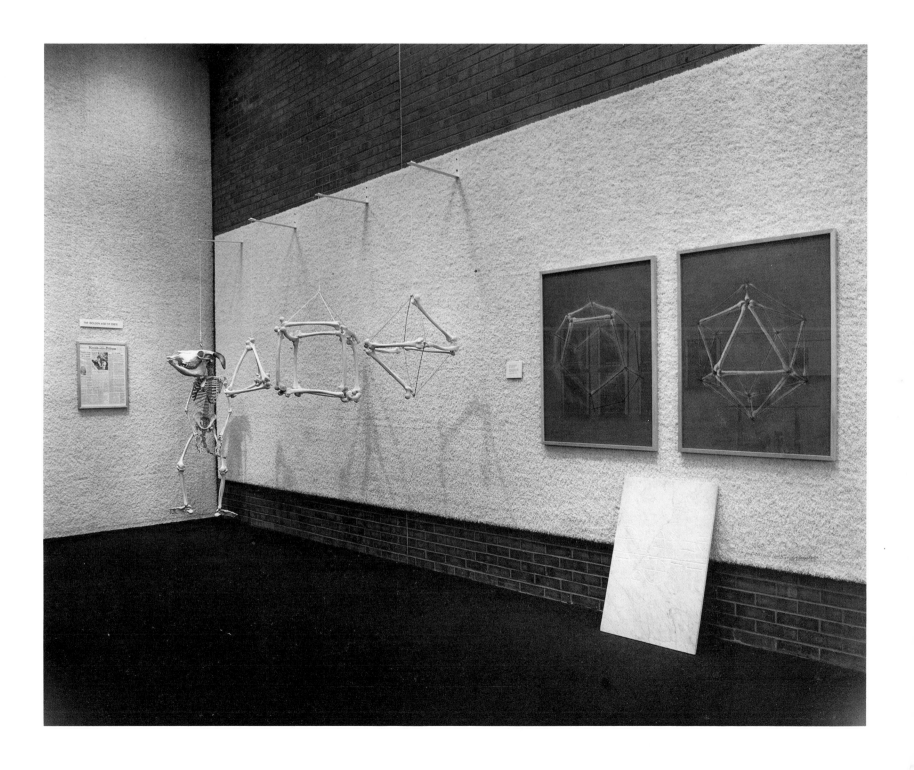

Charles Simonds

127 *Tower.* 1982
 Unfired clay over wood structure, 15 x 28⁷⁄₁₆ x 28 in. (38.1 x 72.2 x 71.1 cm.)
 Purchased with funds contributed in part by Mr. and Mrs. Andrew M.
 Saul and The Associates Committee
 83.3121

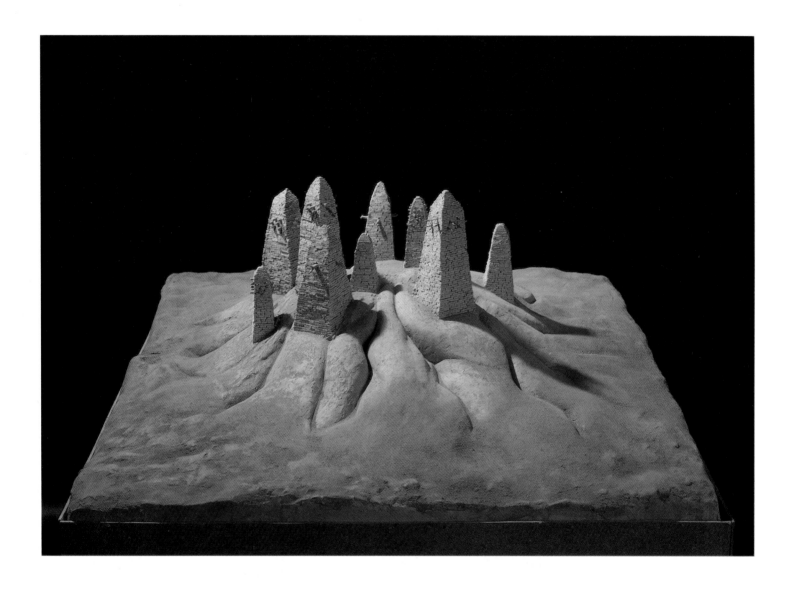

Martin Puryear

128 *Seer.* 1984
Painted wood and wire, 78 x 52¼ x 45 in. (198.2 x 132.6 x 114.3 cm.)
Purchased with funds contributed by the Louis and Bessie Adler
Foundation, Inc., Seymour M. Klein, President
85.3276

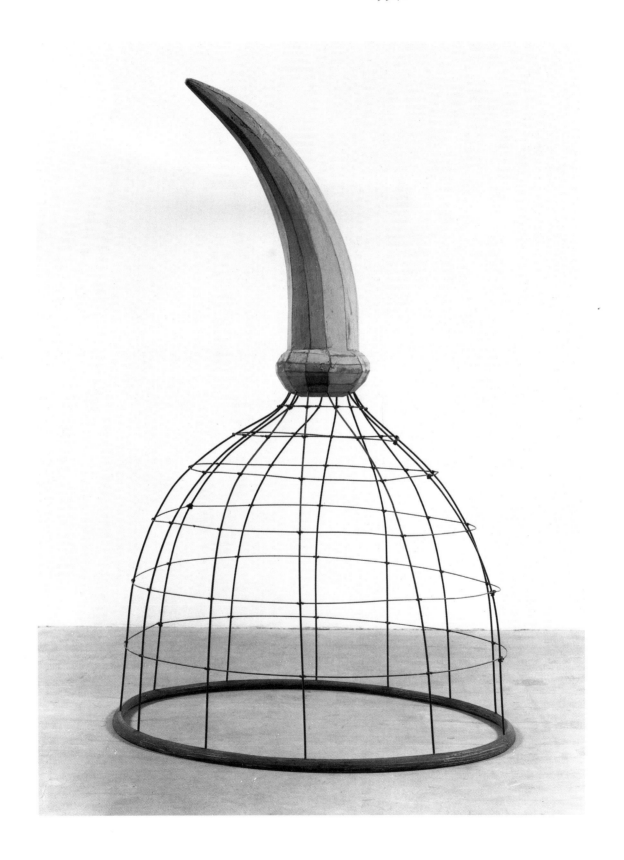

PHOTOGRAPHIC CREDITS

Exhibition 87/6

5000 copies of this catalogue, designed by Malcolm Grear Designers
and typeset by Schooley Graphics/Prime Line Phototype,
have been printed by Arnoldo Mondadori Editore
in September 1987 for the Trustees of The Solomon R. Guggenheim
Foundation on the occasion of the exhibition
Fifty Years of Collecting: An Anniversary Selection.